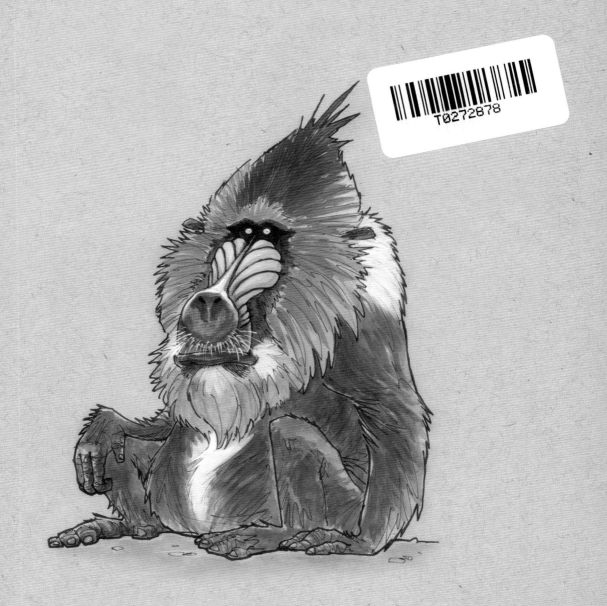

volume one

the daily zoo

keeping the doctor at bay with a drawing a day

Chris Ayers

foreword by J.J. Abrams

 designstudio|PRESS

For Trish,
whose laughter can still be heard.

Contact info:
To contact the artist please visit www.chrisayersdesign.com

Non-labeled Image Titles:
pg. 1: Day 227 - Mandrill
pg. 2: Day 064 - Nuclear Squirrel
pg. 159: Day 062 - Koala
Back cover: Day 327 - Hangin' Out (Baboon)

Copy Editor: Melissa Kent
Book Design & Production Layout: Chris Ayers
Photography credits: Jim Ayers (p.8), Thasja Hoffmann (p.9), Chris Ayers (p.120)

Published by Design Studio Press
8577 Higuera Street
Culver City, CA 90232
http://www.designstudiopress.com
E-mail: info@designstudiopress.com
10 9 8 7 6 5 4 3 2

Printed in China
First Edition, November 2008

Hardcover ISBN 13: 978-193349232-2

Paperback ISBN 13: 978-193349234-6

Library of Congress Control Number: 2008930886

contents

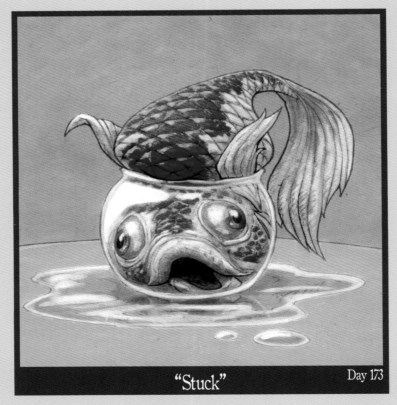

"Stuck"

Day 173

"You *gotta* publish this!" That was the enthusiastic response received when I had the opportunity to show the first sketchbook of *The Daily Zoo* to J.J. Abrams, one of the most talented visual storytellers I know. When he asked, "Have you ever done a goldfish that's too big for its bowl?" the search for that day's animal was over.

I have worked with some spectacular people.

Among them was a woman named Tricia Goken. Tricia was a script supervisor on *Alias*, a series I produced which ran on the ABC network from 2001 to 2006. Trish, as she was known, had a wonderful sense of humor. More than that, really. She was a fellow goof. She was, simply, great to have around. Among the benefits of working alongside Trish was that every year at wrap, she gave every member of the cast and crew a magnificently-rendered, full-color comic drawing of the *Alias* main characters (and a particularly geeky-looking creator).

Full of inside jokes and arcane details specific to the series, these were clearly works of a mad genius. I remember, at the end of season one, seeing the first of these comics. It blew my mind. I begged Trish to introduce me to the artist, and so she did.

It was a good friend of hers named Chris Ayers.

Chris couldn't have been nicer. Suddenly I knew someone who drew as well as I deeply wish I could. See, I admit it – I was instantly jealous. Ayers had an annoying facility with the kind of caricature work that would have made the classic Mad Magazine guys green with envy. But there was more. He could draw, like, ANYTHING.
Realistic still-lifes. Portraits. Photo-real creatures. Landscapes. I realized quickly (as you will, enjoying this amazing book) that Chris Ayers is a nightmare to categorize. Unless you simply put him under the category of Mad Genius (see above).

In early 2005, all of us at *Alias* were shocked – there is no better descriptor – to learn that Trish had been killed in a car accident.
Of course, this is a horrible, tragic thing in the abstract. But to have known Trish…it simply meant pure heartbreak. Her smile and enthusiasm and optimism will be forever missed.

Partially in honor of Trish – and partially because a season without The Cartoon would not have been a full season at *Alias* – I asked Chris to continue the year-end tradition. He graciously did by drawing one of his best cartoons yet. But

not without first telling me that he had been diagnosed with cancer.

Yeah, I know, this is a real upper. Best Foreword Ever, Abrams.

But you need to know the story.

Chris, who had just lost a dear friend, was now battling a life-threatening disease. The unfairness factor hit an all-time high.

One day, while in my office, Chris showed me a drawing notebook he was keeping. Something to distract him during his cancer recovery, he said. A collection of animals, drawn one per day (ARG! Even the concept was brilliant!). I remember just staring at the images and smiling – because they were pure Ayers. Delightful and wildly varied. Funny and beautiful. Exaggerated and realistic. Unpredictable and inspiring and full of vivid LIFE.

And THAT was what struck me.

This young man was going through a devastatingly painful time – and yet his creations were so vibrant, so animated – so HAPPY. This book, still unfinished at the time, was not just FULL of great characters, it was a testament to CHRIS' character.

I am no longer simply jealous of Chris Ayers (healthy now, hard at work on all sorts of TV and film projects). I am also in awe of him. Certainly, his talent speaks for itself – just flip through these pages, you'll agree. But what doesn't speak for itself – what Chris would not dare tell you himself – is that he's a man of great strength. Absolute determination. Ultimate perseverance.

I will always be grateful to Trish for introducing me to this Mad Genius. With *The Daily Zoo: Volume One*, I think she'd be as proud of him as I am.

J.J. Abrams
February 2008

introduction

The doctor returned to the exam room and shut the door behind him. He had just viewed slides of my blood and said, "Well, as you probably know we've got a serious problem." It was April 1, 2005 and I was about to be told that I had acute myelogenous leukemia, a cancer of the blood. April Fool's Day. Cancer. Are you *kidding?* At this point in my life I was working as a character design artist in the entertainment industry and was under the impression that the sore throat and extreme fatigue I had been experiencing for the past few weeks were a result of a bacterial infection or something else rather benign.

Six hours later I was sporting a powder blue hospital gown, looking away as a nurse threaded an IV into my left arm, only half-aware of what was happening. The other half of my consciousness was numb, reeling from this uncomfortable and terrifying label that had been suddenly thrust upon me: "cancer patient." As I lay in the hospital bed that night – feverish, frightened, holding my fiancée's hand, listening to the slow, rhythmic pulse of the IV pump – I was embarking on a journey, one that would be the toughest I had ever undertaken. Ultimately, though, it would also be one of the most rewarding and empowering journeys I had ever experienced. I had no clue that exactly one year later I would be embarking on yet another journey, tough and rewarding in its own way. This second journey, however, would be a *celebration* of completing the first.

My initial hospital stay, which included a first round of chemotherapy, losing my hair, fevers, chills, vomiting, lots and lots of needles, all sorts of tests, two bone marrow biopsies, a lumbar tap, dietary restrictions, and many sleepless nights, lasted just over one month. I had never been continuously indoors for such a long period of time and my eyes welled up with tears when I was finally able to go home and once again feel the breeze upon my face. The rest of my summer was spent in and out of the hospital, undergoing more rounds of high-dose chemo, total body radiation, more biopsies, tests, surgeries, and procedures. My last major treatment, which the nursing staff dubbed my "new birthday," was an autologous stem cell transplant in July, 2005. This was hopefully going to give me my best shot at saying "C-ya" to the Big C. Throughout my treatment there were also innumerable phone calls, cards, emails, care packages, visits – a vast army of love and support, some expected and some surprising.

But this book is not meant to be a blow-by-blow account of my cancer journey – that is a story for another time. This book is about what I chose to do *after* experiencing cancer. By the spring of 2006, after a lengthy recovery period, I was feeling stronger physically and experiencing more energy. My visits to the doctor were less and less frequent and my treatments were reduced to fairly routine follow-up procedures. All signs were looking positive that I was in remission, and I was eager to move forward, though mindful not to forget what I had just gone through and that a relapse was a real possibility. I was energized to make my own, personal art more of a priority in my life. By mid-March 2006, I knew what I wanted to do.

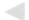 *Receiving a stem cell transplant from nurses Miriam and Ana at the UCLA Medical Center in Los Angeles.*

On the one-year anniversary of my diagnosis, April 1, 2006, I started a sketchbook called *The Daily Zoo*. My intent was to draw an animal each day for a year. This would combine two of my lifelong loves: drawing and animals. I looked forward to challenging both my creativity and self-discipline. But most importantly it would provide an opportunity to *celebrate the gift of each healthy day.* Each animal would represent in a small but very tangible way another successful day in my personal fight against cancer.

So, at some point on each of the following 365 days, I spent a little time with my pals (pencils, pens, brushes; lions, tigers, and binturongs) and slowly filled the pages of *The Daily Zoo*. As my recovery continued and I became more active, the sketches were done not just at my drawing table at home, but in a wide variety of locations: airports, coffee shops, food courts, hotels, cars (as a passenger not a driver!) and, of course, the waiting room at the doctor's office.

Why animals? Because from early childhood they have fascinated me. During my first trip to the zoo a pacifier was lost to the sea lions as I gasped in amazement. One of my first words was "undunt" – my best attempt at "elephant" – and my preschool teacher once reported to my parents that I had taught her that a dromedary camel has only one hump, not two. I have never outgrown that love. The immense diversity of the animal kingdom has provided an endless source of fascination and inspiration. Big. Small. Slimy. Scaly. Furry. Feathered. Spiky. Smooth. Wet. Dry. Fierce. Fanged. Cute. Cuddly. Fast. Slow. *Endless.* And when I learned early on to combine animals with another budding passion of mine, drawing, well…that was it. I knew that somehow, somewhere, animals and art were destined to factor into my life. My current work as a character designer is a perfect fit.

Airports were just one of the various locations where the pages of The Daily Zoo *were filled.*

Life is very complicated but in some ways, deep at its core, also very simple. Life is Short. Life is Precious. Do what you love and love what you do. But, as simple as it is, it is difficult to adhere to that simplicity. Life gets busy. Crazy. Messy. I'm certainly not immune to this – my life gets hectic too – but one of the positive outcomes of my cancer experience is understanding, even more than I did previously, the importance of striving to keep it simple. Find – *make!* – time in your life to do what you love and feed your soul.

Because *The Daily Zoo* was such a rewarding experience, I've continued the project beyond its inaugural year. At the time of this writing, I am nearing the end of Volume Two and blank sketchbooks sit on my shelf, awaiting the start of Volume Three. I can't predict how long I will continue, but as long as it remains fun and challenging and I remain in good health, I may find it difficult to stop.

Keeping the possibilities of your own creativity in mind, I invite you to turn the pages and wander the grounds of *The Daily Zoo.* Enjoy the journey. I know I did.

March 2008

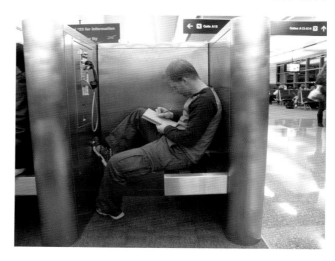

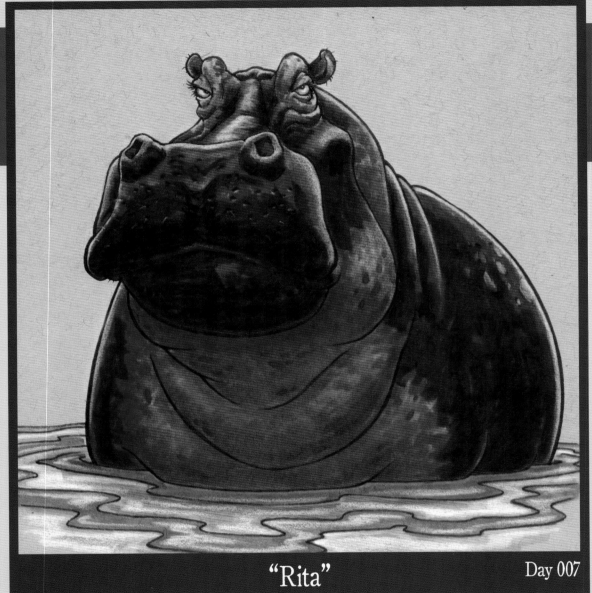

"Rita"

Day 007

In the introduction I mentioned two journeys: my cancer journey and the journey of doing *The Daily Zoo*. While they differed in numerous ways – one was facing my mortality and one was doodling – they did share some similarities. One of these was uncertainty. What would the experience be like? What would be the outcome? Assuming I completed it, how would the journey have changed me? For my cancer journey, that uncertainty was scary and foreboding, a tough fight. For *The Daily Zoo*, however, that uncertainty was fun and exciting, a chance to discover and play!

During my battle with cancer there were a lot of rules. No fresh fruits or vegetables while my white blood cell counts were low. Drink an energy protein beverage with every meal. Take all my pills. Don't floss. Use an electric razor, not a disposable blade. Everyone had to sanitize their hands before touching me. No breakdancing in the hospital hallways. The only rule for *The Daily Zoo* was to make a little time each day to have some fun and draw an animal. There was a lot of latitude with the style of the drawing, the medium used, or even the subject matter itself. (I don't know of any other zoological institution that has "hungry rocks" as a part of their collection.)

Be creative. That was *The Daily Zoo's* essence. My theory is that the more people allow themselves to entertain their creative sides, the more sane and better off this world of ours would be. Perhaps it is a little naïve, yes, but if more people embraced creativity, rather than stifling it, I think only good could come of it. A blank page should not be a frightening thing. Some of us may need more coaxing than others to awaken our creative beast, but it is there within us all. So, go! Get out there and *create*, whatever the medium! Draw! Paint! Sculpt! Cook! Sing! Recite some Shakespeare! Play the piccolo! Play with your food! Write a mystery! Invent time travel! Solve the world's energy problems! Brainstorm upside down! Plant a garden! Carve a hunk of wood! S-t-r-e-t-c-h those creative muscles! Don't let fear, insecurity, perceived lack of ability, or ornery hippos stand in your way.

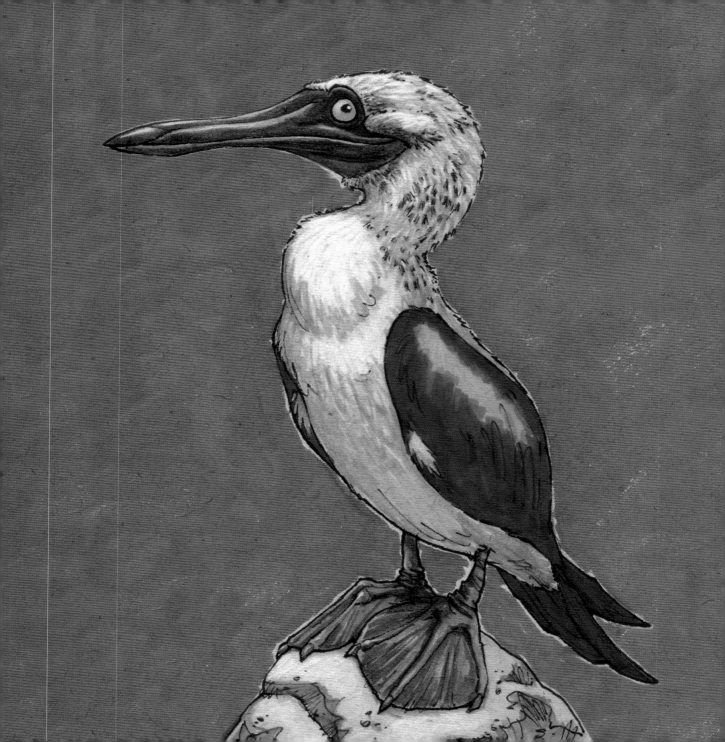

Mr. & Mrs. Hammer at the Opera

After focusing on beginning the project with a booby for several weeks, I realized when Day 002 came around that I had given absolutely no thought to what would come next. I was flooded with ideas and it was hard to choose just one. I had to remind myself that there would be 363 more opportunities so I didn't have to be *too* careful with my decision. (Observant viewers may notice the hammerhead-proportioned opera glasses.)

DAY 003

Grizzly

This style was a bit of a departure for me. I tried using markers and colored pencils in a more painterly manner. One of the goals of *The Daily Zoo* was to experiment and play.

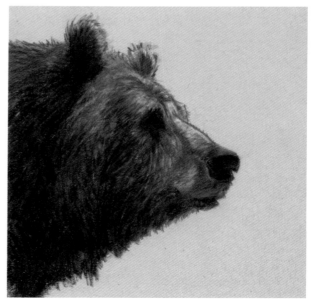

DAY 001

Blue-footed Booby

I had the idea for *The Daily Zoo* in early March 2006. I bought a suitable sketchbook and it was "Ready! Set!...Wait." For sentimental reasons, it was important to start the project on April 1st since it marked the one-year anniversary of my leukemia diagnosis. I really wanted the project to be a daily reminder of that experience and the fact that, so far at least, I had come out on top. I'm not sure why, but when the idea to do *The Daily Zoo* popped into my head, a vision of a blue-footed booby tagged along. For the several weeks I was anxiously waiting to start, I knew what the first drawing would be.

Binturong

This day's sketch was done at the Venice Grind, a local coffee shop. Many of *The Daily Zoo's* fauna were created in coffee shops, libraries, or shopping mall food courts. Sometimes it is easier for me to focus in a public environment, surrounded by the anonymous hustle and bustle, than at home. I can plug into music and lose myself for hours.

Binturongs, or bear cats, are rare arboreal mammals native to Southeast Asia. They are the only "Old World" (meaning from Africa or Asia) mammal with a prehensile tail and their scent glands give off a smell like buttered popcorn.

DAY 011 ▶

Drop of Cardinal

I thought a fat little cardinal would be fun. I exaggerated the pointed crest and bulbous body which gave me the piece's title. The original sketch was done with pen and markers. I later added the background digitally in Photoshop and used the version seen here as my holiday card the following winter.

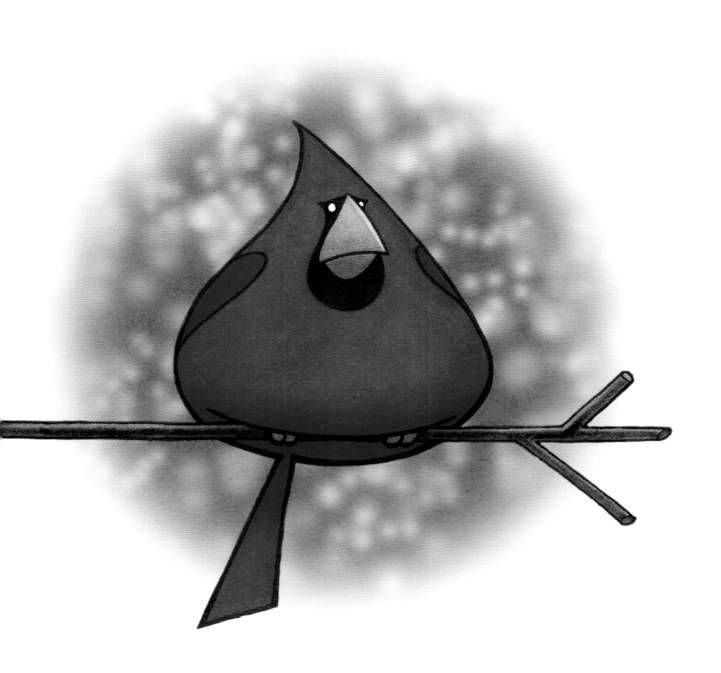

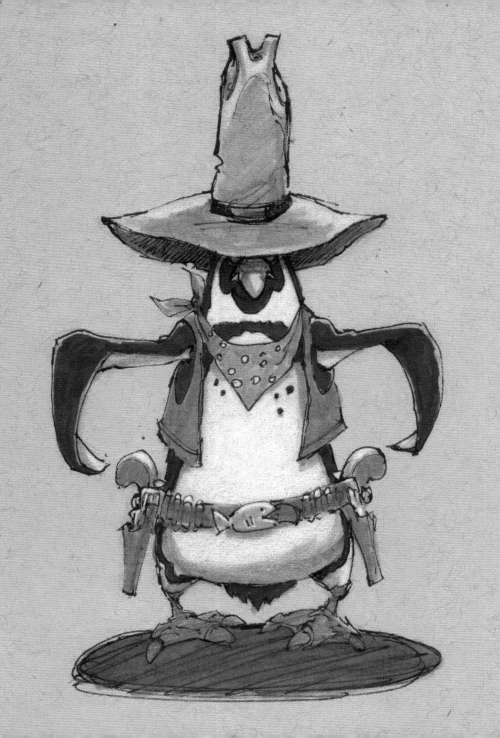

DAY 012

The Penguin Who Made My Day

This guy started out as a normal penguin, not an aquatic gunslinger. I began lightly sketching in pencil and got the feet to work, but the body and head were giving me a lot of trouble. Thank goodness for erasers. After numerous attempts, the cowboy part just sort of happened – I think partly as a result of his inward-pointing toes and slight bow-leggedness. Once I had a direction for his character, it started to come together. Perseverance doesn't always result in success, but in this case I feel it did. After initially fearing this sketch was doomed, it turned out to be one of my favorites.

DAY 014

Konstable Komodo

I'm not sure exactly how a Komodo dragon, native only to a few islands in Indonesia, ended up strolling the cobblestone streets of Victorian-era London but that's what happens when you have an itch to draw both a Komodo and an English bobbie without much regard to the relative absurdity of it. I find the "anything goes" freedom of drawing in a sketchbook continually refreshing.

DAY 019

Tortoise

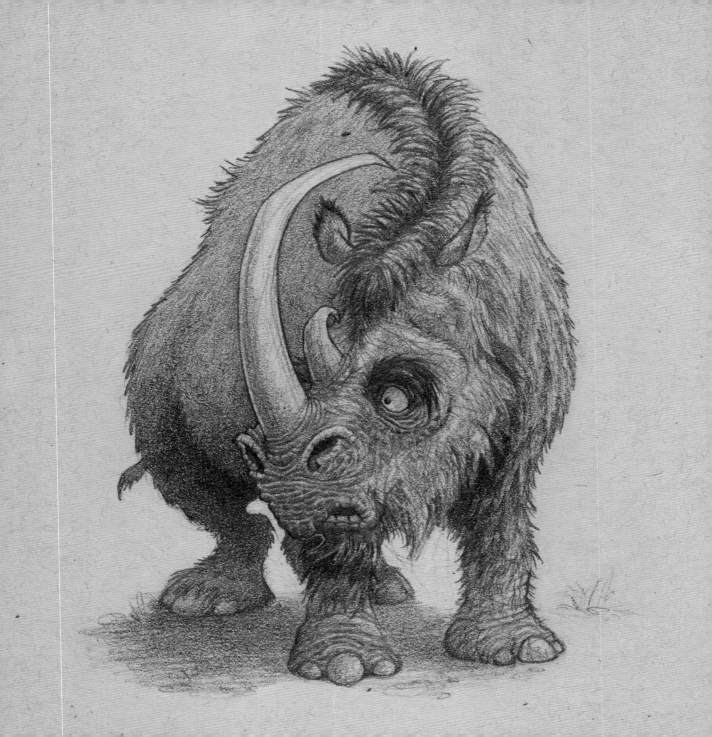

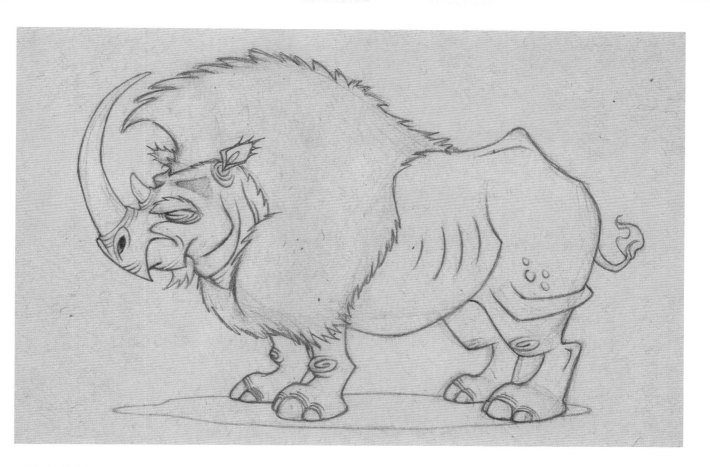

DAY 023 ◀

Rhinocerotid

I was reading *National Geographic* on this day and came across an article on prehistoric mammals. It is one of the few periodicals I try to read cover-to-cover because it does such a good job of doling out a monthly glimpse into the amazing stories and sights of our fascinating and diverse world. Plus it provides wonderful visual reference material.

DAY 024 ▲

Rhinocerotid...Again

This is the first instance in *The Daily Zoo* of drawing the same subject matter on consecutive days, something I repeated on several more occasions. Sometimes I did this because I was not thrilled with the first result and felt the need to try again. Sometimes, as in the case of these rhinocerotids, I simply wanted to try a different approach. When designing a character, if time allows, I like to do a lot of drawings to explore variations in style, proportion, silhouette, attitude, texture, etc. Most of the sketches in this book, however, are first stabs at an idea, each one being the start of a potential journey. There are many that I think would be fun to develop further.

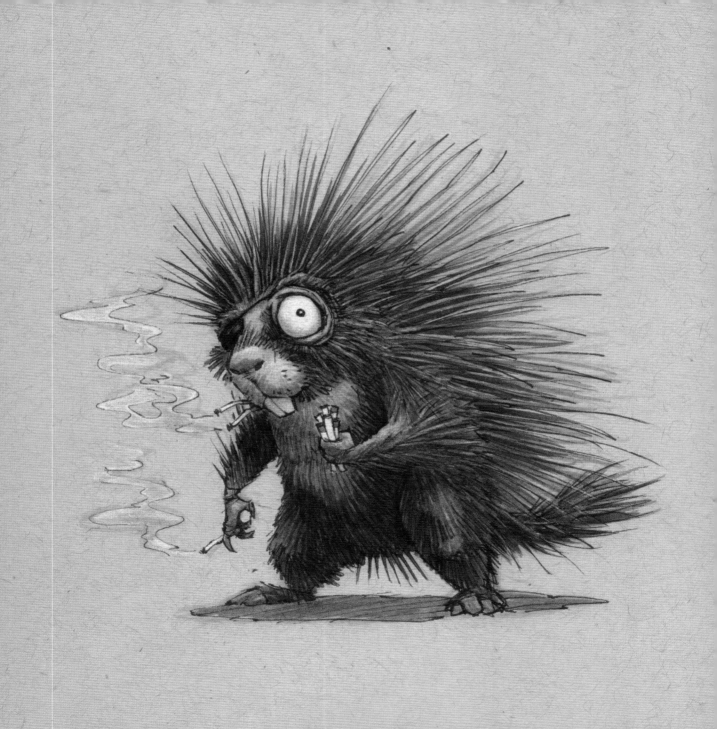

DAY 027

Prickly Puffer

Kids, don't try this at home...or any-where else for that matter. I did not plan for this guy to be puffing on an entire pack of cigs at once, but as the sketch developed it seemed to fit his frayed expression and personality.

DAY 030

Flamingo Fu

Urusai Umou, a wise whooping crane sensei, studied with monks in the Japanese highlands as a part of the Trans Pacific Avian Exchange program. After failing to control his loud whooping in numerous attempts at a vow of silence, he was ostracized and asked to leave the peaceful monastic community. He returned home to Boca Raton, Florida, and set up shop teaching his pink-feathered brethren the martial arts, demonstrated here by his prized pupil Deuce McCoy.

Often when I'm drawing a character, even if for no specific project, I like to imagine his or her backstory. Who is he? Where did she come from? Why does she dress that way? Why is he deathly afraid of the color beige? Even if this information is solely for my entertainment, it can help the creative flow and design process by adding a subtle level of credibility to the character.

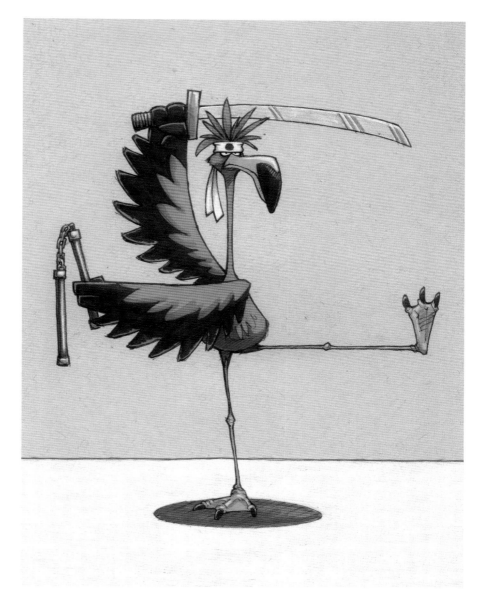

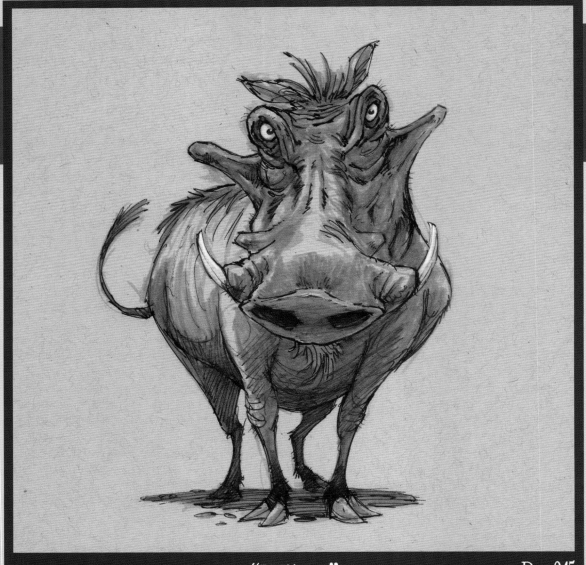

"Wilcox"

Day 045

Shortly after my diagnosis and initial round of treatments I spoke with Jan, a friend of my parents, who had been diagnosed with non-Hodgkin's lymphoma, another type of blood cancer, several years before. She had traveled a similar road to the one I would be traveling in the coming months, going through multiple rounds of treatment and culminating in an autologous stem cell transplant (one that uses stem cells harvested from yourself as opposed to a donor). Talking to a doctor or doing research on the Internet could only tell me so much. Talking to someone who had actually gone through it helped immensely to fill in some of the gaps. It didn't erase the fear, but it helped dampen it.

Several months after my last treatment, as I was progressing along the road to recovery, I got to return the favor in a sense, when my oncologist asked if I would speak to one of his newly-diagnosed leukemia patients who was about to embark on a similar journey. The warthog on the opposite page was drawn at a shopping mall nearby after visiting the patient at his home.

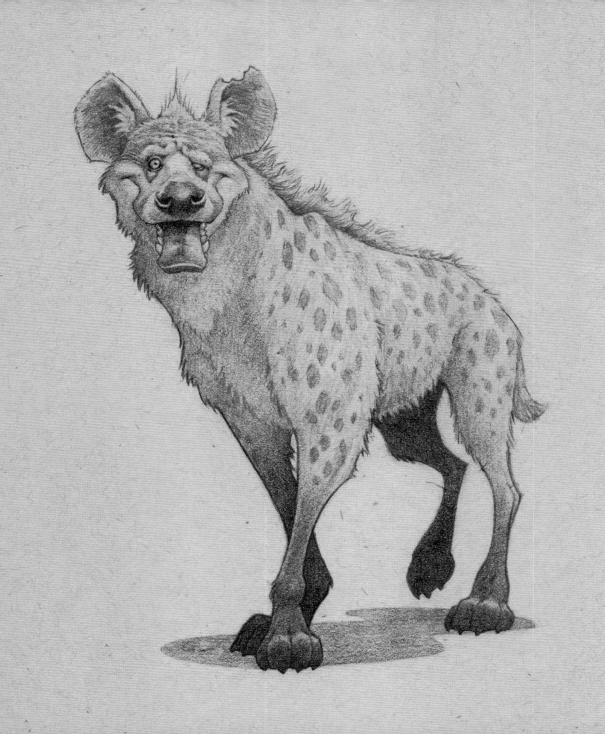

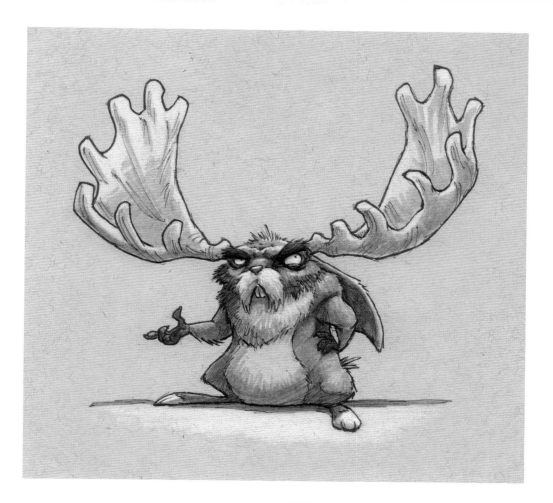

Hyena

Hyenas have great shapes and proportions: a thick, strong neck and shoulders; long, powerful legs; big ears. They look sort of like an über-dog, though technically they're not in the canine family.

Jackamoose

Most people are familiar with the jackalope – that fabled horned hopper of the Great Plains – but this is a jackamoose, the French-Canadian cousin of the jackalope. His name is Jacques Jean-Pierre and he is one of the characters in the children's book I'm currently writing and illustrating.

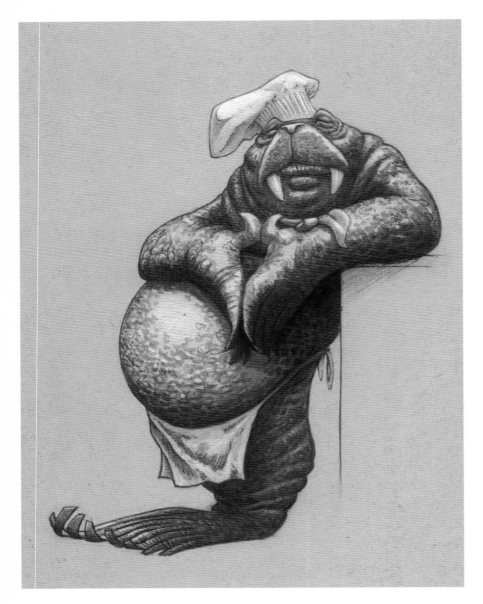

DAY 035 ◀

Walrus at the Waldorf?

Sometimes the subject matter will influence the choice of media and sometimes the choice of media will influence the subject matter. The brown felt-tip pens I picked up on Day 035 lent themselves well to the rusty coloration and bumpy texture of this walrus chef.

DAY 036 ▶

The Evolution of Echo

Echo the Elephant was born as a small ink sketch on Day 036. He was one of many loose pachyderm thumbnails done that day - a process that is great for quickly exploring a large variety of ideas. My fiancée Thasja, who has long adored elephants, quickly found her favorite, which I later cleaned up using Adobe Illustrator and turned into a car window decal for her birthday (his name comes from the make of her car). Echo is probably one of the few elephants in the world whose natural habitat consists of the Los Angeles freeway system.

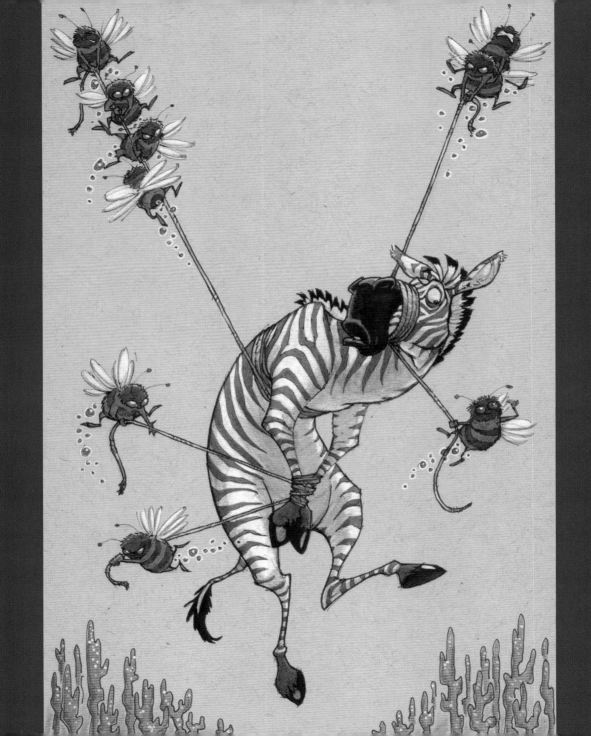

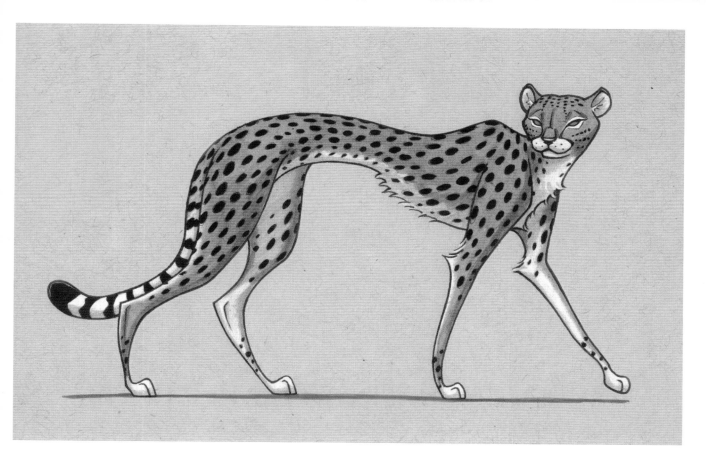

DAY 040 ◄

Beware the Bumblefairies!

Occasionally I asked someone else to suggest an animal to draw on a given day. In the case of Day 040 Thasja requested, "A zebra...no, wait...how about a fairy?" I thought it might be fun to combine the two into a bit of extra-terrestrial ungulate bondage. Initially she was disappointed that the fairies were more like bumblebees than the traditional slender, feminine fairies with flowing translucent gowns and gossamer wings, but eventually she came around to appreciate the oddity of the scene.

DAY 041 ▲

Cheetah

The cheetah possesses sinewy grace and elegance, which I tried to capture by accentuating her sleek and slender form while spending time at the local library one afternoon.

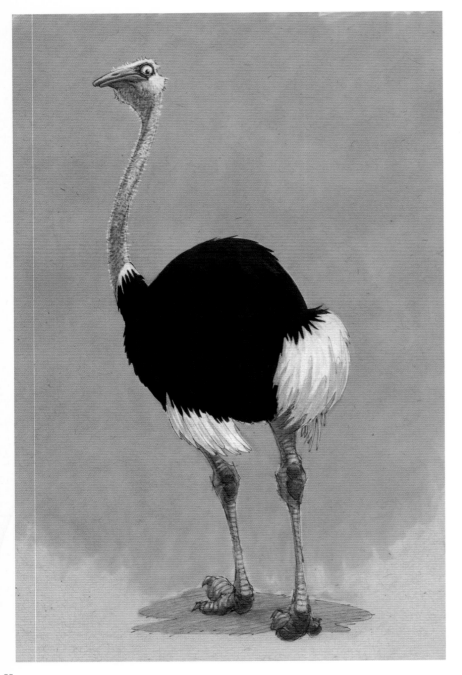

Ostrich

This drawing is based on a photograph I took at the Los Angeles Zoo. With sketchbook and camera in hand, I try to frequent zoos and aquariums, since there is no substitute for observing live animals. One can study an animal's anatomy, locomotion, behaviors, and even personality (or is that 'animality?') better in three dimensions than from a flat image in a book or on a TV screen. Having said that, I unfortunately do not have a herd of giraffes in my backyard and do end up drawing from photographic reference quite a bit.

Time to Fold?

When drawing an animal, I enjoy subtly playing up characteristics that are unique to that species, such as the eight tentacles of this octopus. I also try to get inside the character's head. What would *I* do if *I* had eight arms? Tour with a circus as a master juggler? Slice, dice, flip, fry, beat, bake, baste, and braise as a world-class chef? Invent astonishing, never-before-seen moves as an all-star wrestler? The possibilities are endless! One thing is for sure: I think it would be fairly easy to entertain oneself if you had eight limbs, as this guy seems to be doing.

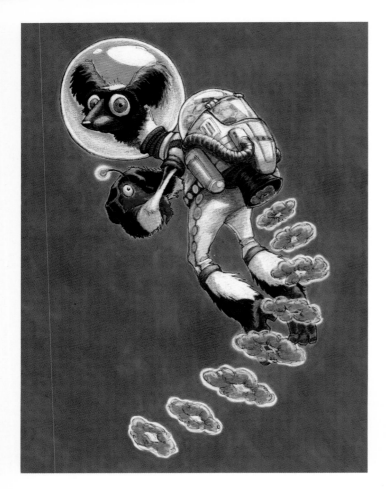

DAY 061 ▶

Lioness

This was not much of a creative challenge other than translating a photograph into a drawing, more a technical exercise in rendering and observation than anything else. Yet those things require practice as well. It was one of the few drawings that I timed, and the two hours and six minutes it took to complete made it one of the more time-intensive *Daily Zoo* entries.

DAY 056 ▼

Izzie Head Studies

I wanted to try a few more passes at Izzie's head the following day.

DAY 055 ▲

Izzie

Izzie the Indri is an Interstellar Ice Cream Vendor and, as with the jackamoose on Day 033, also an inhabitant of the children's book which I have been working on for the past several years as a side project. After my cancer experience, I decided to make my personal art projects more of a priority.

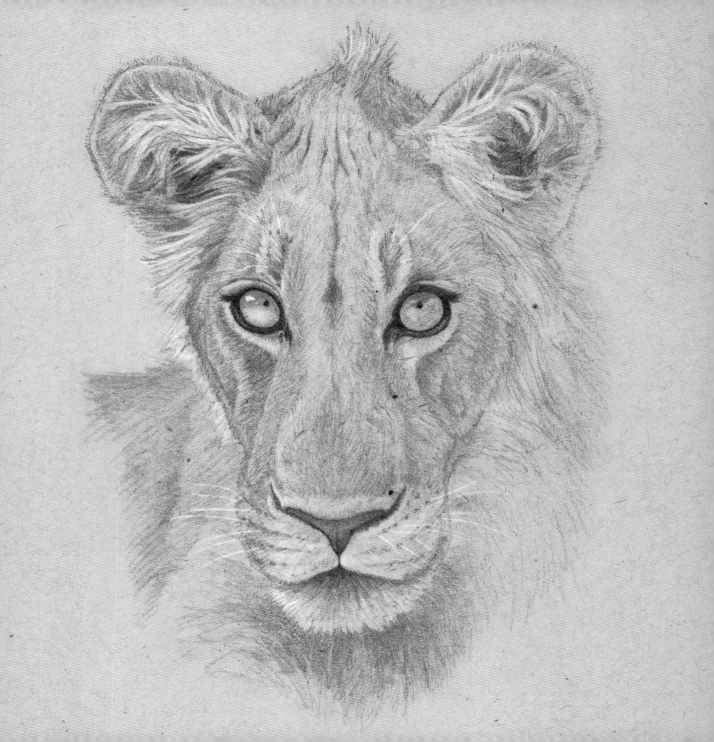

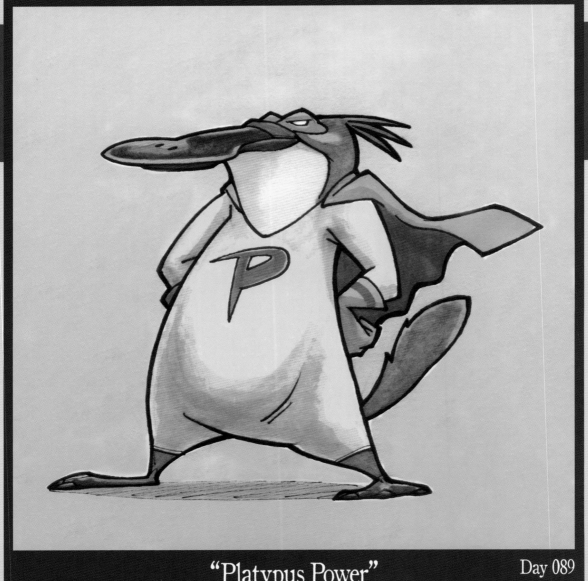

"Platypus Power" Day 089

june 06

Unlike many comic book characters, my exposure to radiation and highly toxic chemicals during my cancer treatment didn't give me superpowers. It did not give me the power of flight, though I had some pretty wild flights during my feverish delirium. I could not climb walls — some days I couldn't even climb out of bed. Nor did my muscles double in size, but my feet did swell to hobbit-like proportions due to fluid retention. It didn't even turn my skin green, though the chemo *did* turn my urine green…and blue…and orange…. Being a cancer survivor, I feel a strange dichotomy of extreme fragility and empowering strength. After enduring such a treacherous journey and coming out on the other side, one can't help but feel a little bit like a superhero.

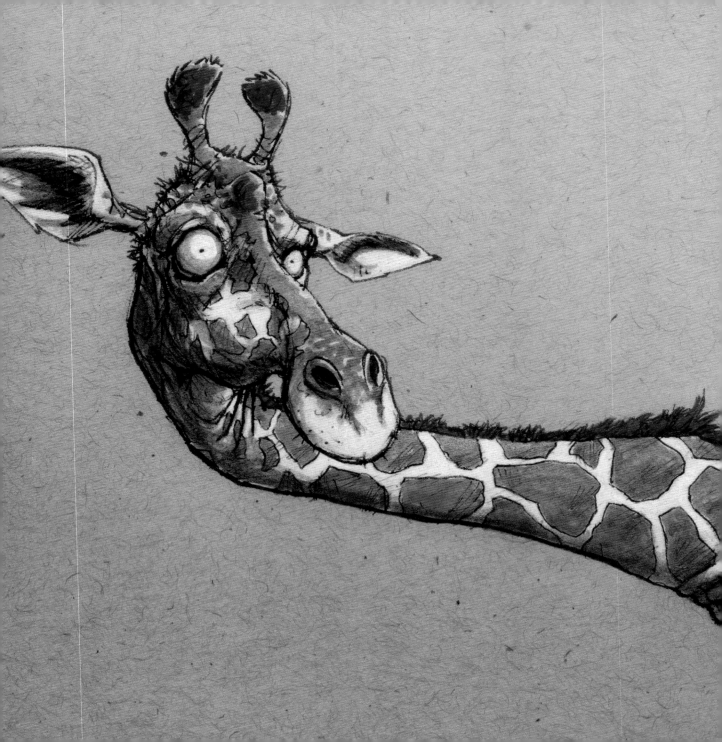

DAY 063

Giraffe

Day 063's giraffe was my original choice for the cover of this book. I liked his slightly bewildered expression and he was compositionally dynamic. However, my publisher discovered another book of animal art with a cartoon giraffe on the cover (*groan!*) and we agreed that it would be better to try something else. It turned out to be a good thing as it forced me to explore other alternatives and to create new cover artwork, something I hadn't previously considered. Sometimes road blocks lead you to discover a better road.

DAY 067

Demonic Imp

The traffic is nobody's favorite aspect of Los Angeles, but *avoiding* traffic can be very beneficial. When working for clients a distance from home I try to avoid evening rush hour whenever possible by killing some time drawing in food courts or coffee shops. This drawing was started on my lunch break at Amalgamated Dynamics, Inc., a creature effects shop in Chatsworth, and finished later that evening at the Northridge Mall food court. Since the date was June 6, 2006, I chose to do a devilish henchman.

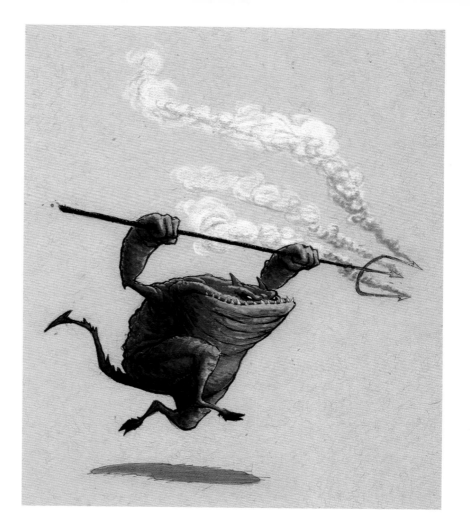

DAY 073 ▽

Encounter

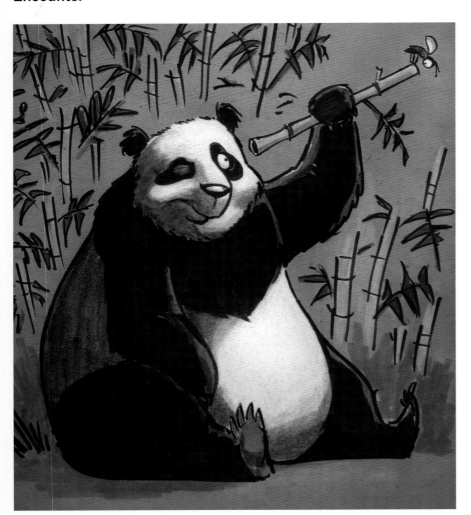

DAY 076 ▷

Bamboo Bob

Day 076's allotted *Daily Zoo* time was spent doing studies of Bamboo Bob, another character from my upcoming children's book. He's a laid-back babirusa with an affinity for floral print shirts. If you're ever in Bahana Bay, be sure to visit Bob's Deep Drop Dive Emporium, your one-stop scuba shop, where you'll find everything from equipment rental to diving lessons to support groups for claustrophobic divers. Nowhere will you find a larger selection of Hawaiian print wetsuits and snout-friendly snorkels.

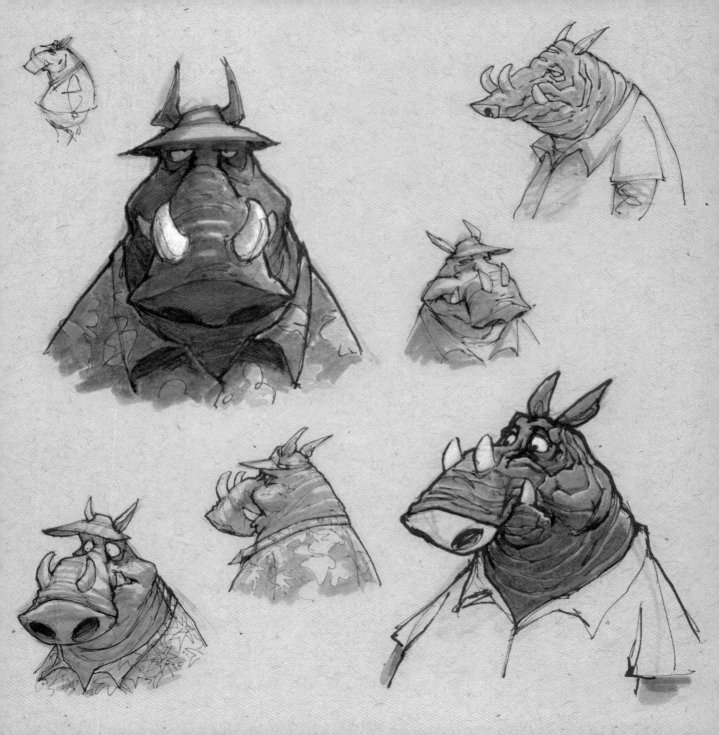

DAY 085 ▶

King of the Pillow Fort

This proud lion was drawn in one of the more unique locations featured in *The Daily Zoo*: a pillow fort in an Anaheim hotel room. Over dinner one night with Thasja and two of our close friends, we reminisced about building childhood forts constructed from sofa cushions and blankets. Months later Sean, Garth, and I decided to surprise Thasja for her birthday with the mother of all pillow forts. We used clothespins, duct tape, mattresses, box springs, rope, lamps, sleeping bags, and of course a great number of pillows. The day's sketch was done quickly, within the safe confines of the fort, because my celebratory ice cream was melting.

DAY 086 ◀

Cassowary

One of the goals of *The Daily Zoo* was to experiment with new media and techniques. Both this cassowary and the tyrannosaurus rex on the opposite page were done using gouache, a type of water-soluble paint that I had not had much experience with. Learning a new medium takes experimentation and patience. My comfort level usually proceeds in small steps as I discover what works and what doesn't. It can be both a very frustrating and a very rewarding process.

DAY 090 ▶

Tyrannosaurus Rex

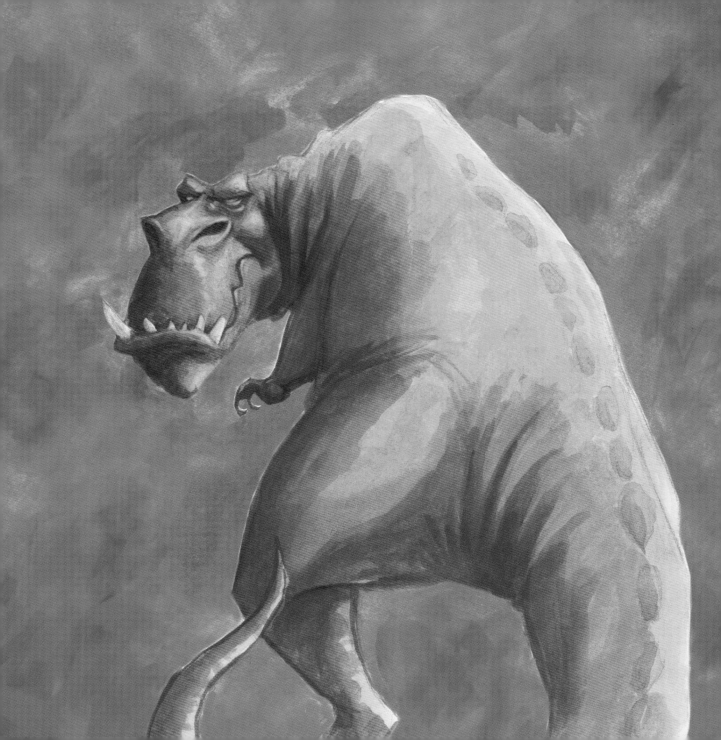

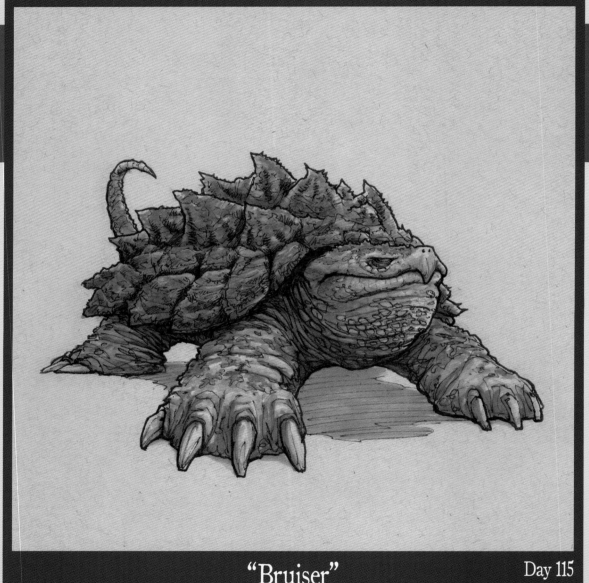

"Bruiser"

Day 115

july 06

The snapping turtle drawn on Day 115 is an apt visual metaphor for the recovery process I went through after each round of chemo: stubborn and slow. The general idea of chemotherapy is to flood your body with highly toxic chemicals that seek and destroy the rapidly reproducing cancer cells (common side effects of hair loss and nausea are a result of the chemo drugs indiscriminately also killing hair cells and cells that produce the protective lining of your stomach, both of which also reproduce at a rapid rate). In my case, after each round of chemo destroyed as many abnormal white blood cells as possible, I had to wait patiently for my body to slowly produce healthy white blood cells. After the initial round of chemo, my body was particularly stubborn. I remember getting my daily lab report only to be dismayed that my white blood count had gone from 0.15 to 0.19 (I needed to get over 4.0 to get the green light to go home). Once my counts had risen sufficiently and put me at a lower risk for infection, I was able to go home for a short period before returning to the hospital for the next round of treatment.

DAY 092 ▶

Kangaroo

For me, going to an art store as an adult is like visiting a toy store when I was younger, eyes popping in wonder at the endless shelves filled to the brim with enticing and colorful playthings. I love finding new types of art supplies to try. This kangaroo was done with a water-soluble graphite pencil, something that was relatively new to me. I drew the sketch first and then selectively added water to it with a brush.

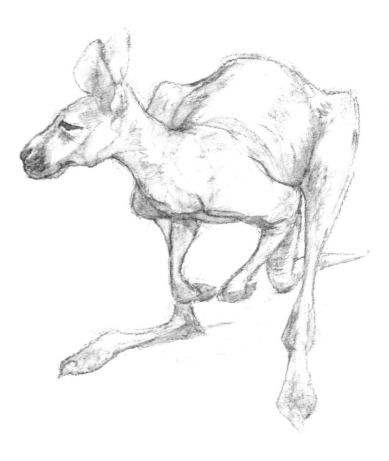

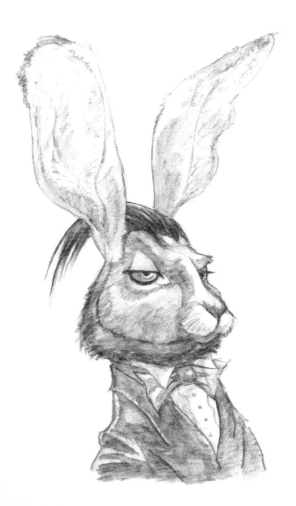

DAY 095 ◀

Rabbit. *Jack* Rabbit.

For Day 095 I had a vague idea of a rabbit in a tuxedo. As the drawing progressed I started envisioning him as an unflappable secret agent. The resulting sketch is a starting point which I will perhaps someday revisit to develop further.

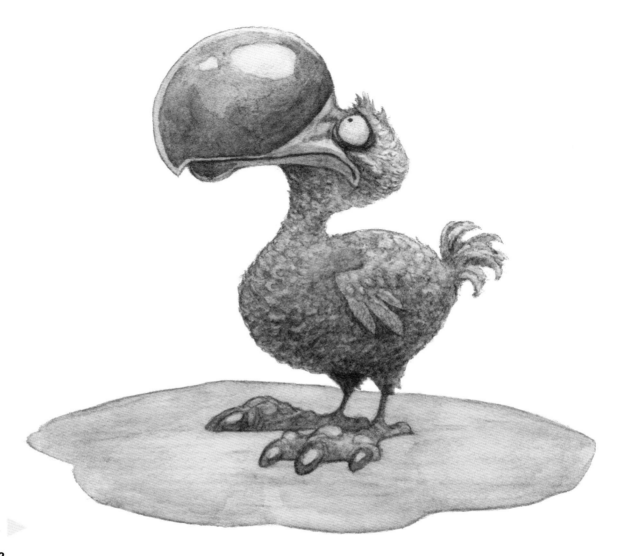

DAY 094 ▶

The End?

This is Ditto, the last of the dodos. What could the ominous shadow falling on him be? A meteor? A voracious predator? Colonel Sanders' great-great-great-great-great-great-grandfather? Or perhaps just a cloud blocking the sun? We'll never know for sure.

Yodaphant

I know Yoda never had a trunk, but *Star Wars* seeps into my brain in weird ways sometimes. As a kid the characters, monsters, spaceships, and exotic locales sparked my imagination and inspired countless hours of play and drawing. The influence of the Force continued into my adult life. During those long hospital stays, weak and tethered to an array of machines through a sea of tubes, I sometimes would try to do positive visualization. I wasn't sure it would aid the healing process, but I also figured it couldn't hurt. One of the visualizations I came up with was watching miniature Jedi Knights soar through my bloodstream, cutting down the leukemia cells one by one with their lightsabers. (The chemo made me lose my hair, but not my geek quotient.)

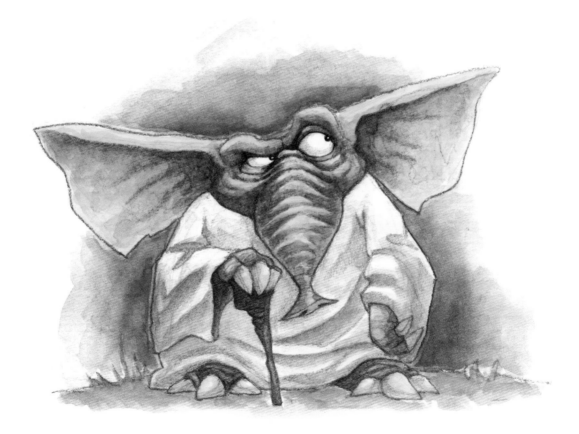

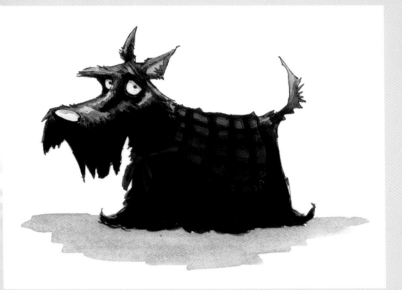

DAY 106 ▶

Wood Duck

Wood ducks, one of the few species of ducks to nest in trees, are some of the most colorful members of the water fowl family and, if this guy is any indication, also some of the most literate.

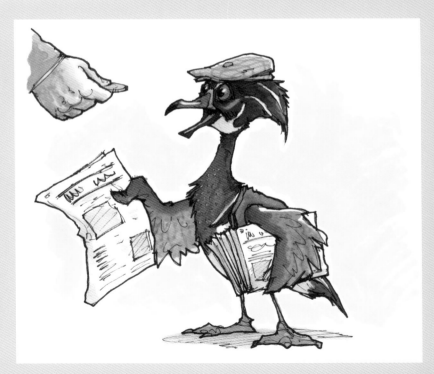

DAY 109 ▶

All Aboard!

There is something magical about trains. They embody a sense of adventure; a journey to new sights, smells, and sounds. A conductor shouting, "All aboard!" over the sound of a steam locomotive slowly chugging into motion evokes in me an odd sense of nostalgia even though it is not something that I have experienced firsthand.

DAY 111 ▲

Anteater

I don't know exactly where this guy is going, but I *am* confident he is going to get there. Perhaps he's on his way to register a complaint with the extermination company that mistakenly wiped out a month's worth of dinners.

DAY 112 ▶

Burly Benjamin the Blacksmithing Bear

Using a limited tool set, such as the few gray-toned brush pens for this sketch, can provide a good challenge. Much of my professional art occurs at least partially in the digital realm. The graphics software available these days is extremely powerful, limited only by the user's imagination and technical prowess. At times the sheer number of options and tools can be overwhelming. Having to create an image with just a few tools can sometimes guide me to results that I might not have discovered otherwise. In the case of this bear, the brush pens did not allow as much control and detail as a fine felt-tip pen, and certainly no CTRL+Z "undos" of working digitally, so it forced me to be looser in my drawing style.

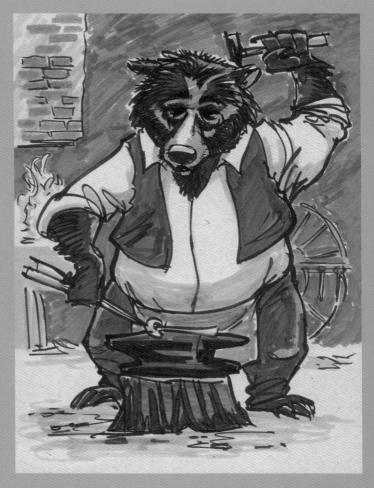

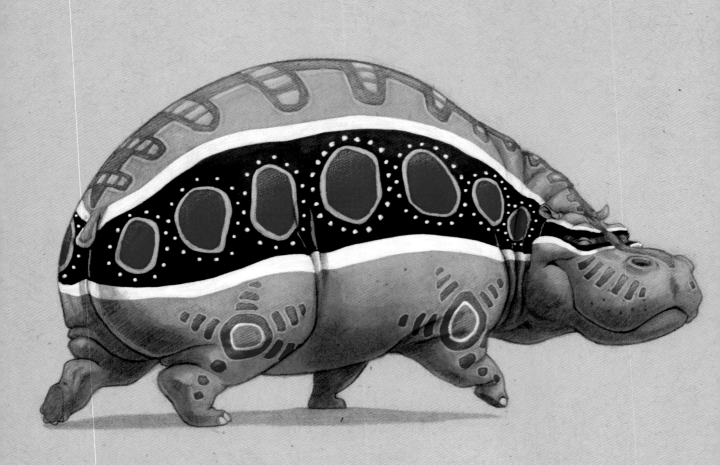

DAY 114

Polychromatic Hippo

For this one, I was inspired both by tribal markings of certain aboriginal cultures and by the practice of painting elephants for festivals in parts of India. I would imagine an elephant, or a hippo for that matter, would be a body painter's dream. What a canvas!

DAY 116

The Golden Voyage of Swinebad?

Like many of my creature effects and animation colleagues, I'm a huge fan of the stop-motion animation work of Ray Harryhausen in such films as *The Golden Voyage of Sinbad*, *Jason and the Argonauts*, and *Clash of the Titans*. Seeing his creations creep, crawl, and slither inspired me to make my own clay monsters as a kid.

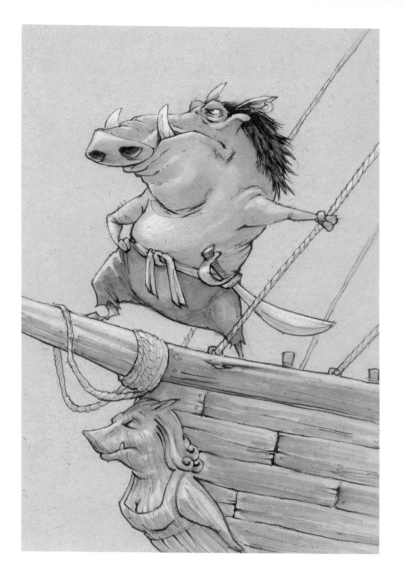

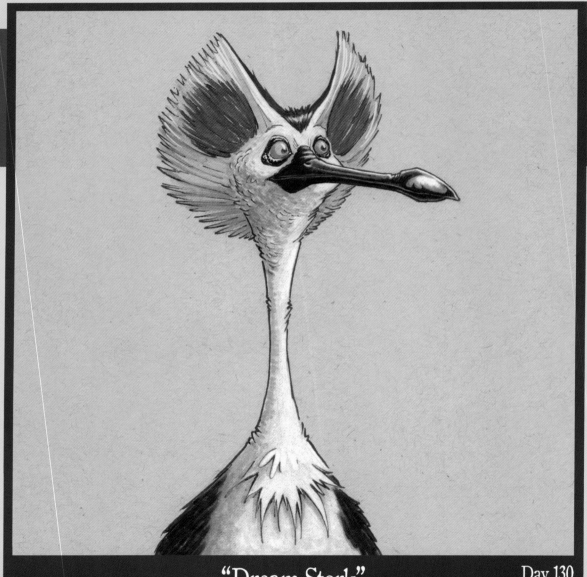

"Dream Stork" Day 130

august 06

Where do ideas come from? Sometimes they pop into our heads instantly and sometimes they slowly grow out of individual fragments of thought to finally make some sense in our jumbled brains. As far as *The Daily Zoo* is concerned, I cultivated my ideas from a variety of sources. I start by trying to always keep my eyes open to the world around me. Inspiration can be found everywhere in the colors, shapes, people, stories, environments, and life that constantly surrounds us. I also like flipping through books and magazines, playing with and reversing stereotypes, taking trips to zoos and museums, drawing something pertaining to a particular event of that day, and asking friends for requests. Some days, when my mind is as blank as the page I'm trying to fill, I'll consult my Zip-loc grab bag (filled with scraps of paper, each with an animal, object, verb, or adjective written on it) or do a scribble exercise (making a random pencil mark and then turning it into a character). Also, it doesn't hurt to work in a field where I'm surrounded by a plethora of talented and inspiring artists. Being exposed to their work pushes me to try new things and to strive to improve my own work. I also have some pretty wild dreams, such as when this colorful stork appeared during one night's slumber.

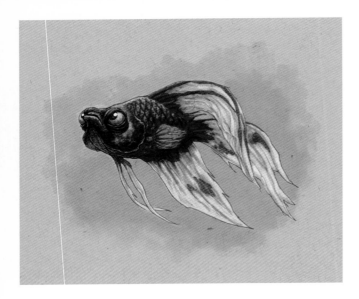

Ode to a Carver

My dad requested an ivory-billed woodpecker on the day we returned from the cabin. Ivorybills had been thought to be extinct since the mid-1900's, but there have been a few possible sightings in recent years, setting the ornithological community aflutter with both excitement and controversy. Dad has been an avid woodcarver and bird-watcher for most of his life. For nearly the past two decades he has combined these dual passions and spent much of his spare time perfecting the art of "fan-carving" birds out of a single piece of wood. I thought it only fitting that for this day's sketch the birds were carving him.

DAY 131 ▲

Beta Fish

Our pet beta, Doug.

DAY 137 ▷

Por Favor

Both Day 137 and the ivory-billed woodpeckers on the opposite page were requests. My sister's friend, Tessa, requested a Weimaraner named "Por Favor." I had only a vague idea of what a Weimaraner looked like. Tessa told me to think of photographer William Wegman's dogs – those were Weimaraners. I had no access to any reference material because at the time we were enjoying a family vacation in a remote cabin in northern Minnesota. Incidentally we had planned this trip for the fall of 2005, but the arrival of the leukemia that spring forced a postponement. When we finally got to that cabin a year later, it was all the more special considering the arduous journey we had all just endured.

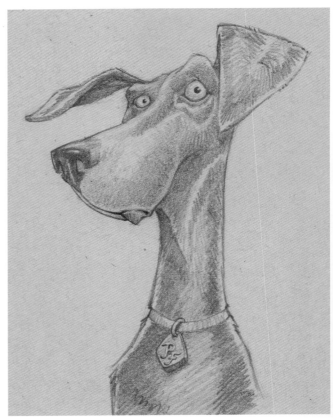

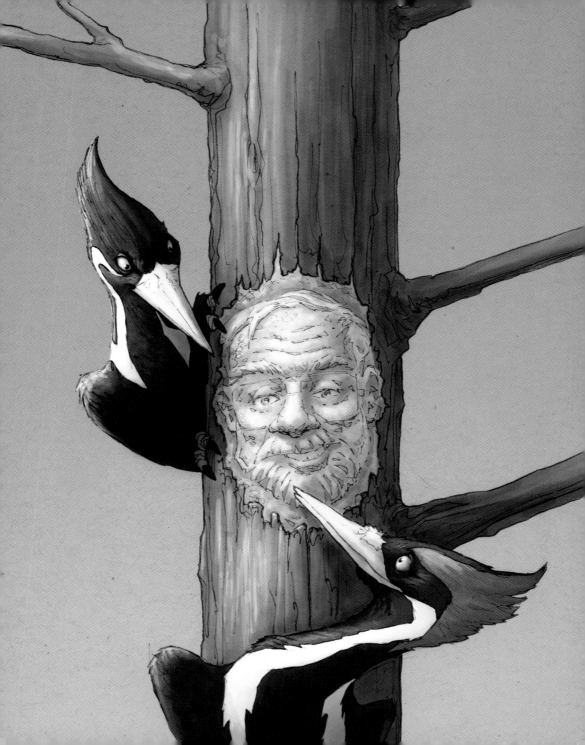

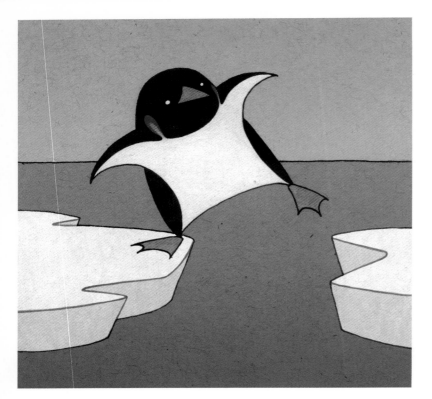

DAY 146 ◀

Ambition

Similar to the *Drop of Cardinal* on Day 011, I was trying to simplify the forms and patterns of this penguin into interesting geometric shapes. I enjoy experimenting with different drawing styles such as hyper-realism, cartoons, and in this case graphic stylization. All provide different opportunities for exploration and switching between them helps to keep things fun and exciting.

DAY 150 ▼

"Where's the *love*, man?!"

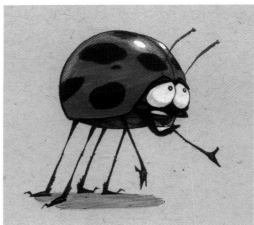

DAY 151 ◀

Slug

This is an example of *The Daily Zoo* being inspired by the events of the day. I had just played a roller hockey double-header and felt exactly like a slug.

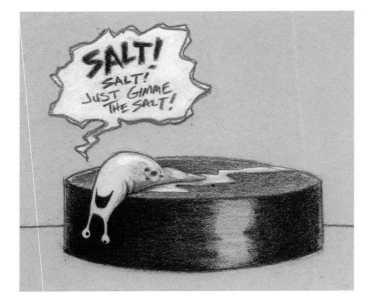

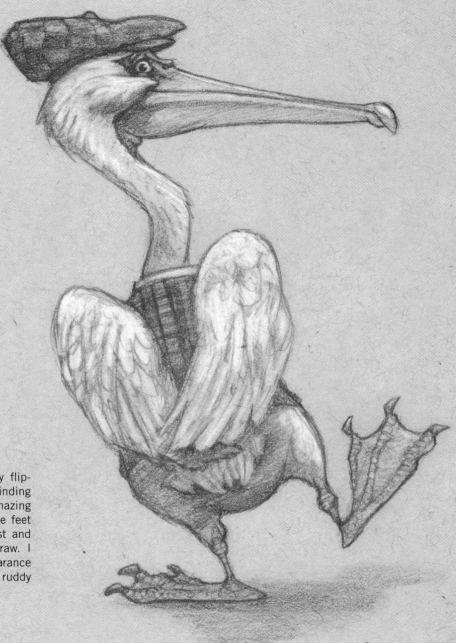

DAY 147 ▶

Paddy O'Pelly

Paddy the Pelican came about by flip-
ping through a magazine and finding
an article on these strange yet amazing
birds. Their serpentine necks, large feet
and long beaks piqued my interest and
provided some great shapes to draw. I
let their somewhat comical appearance
guide Paddy's personality toward a ruddy
cheerfulness.

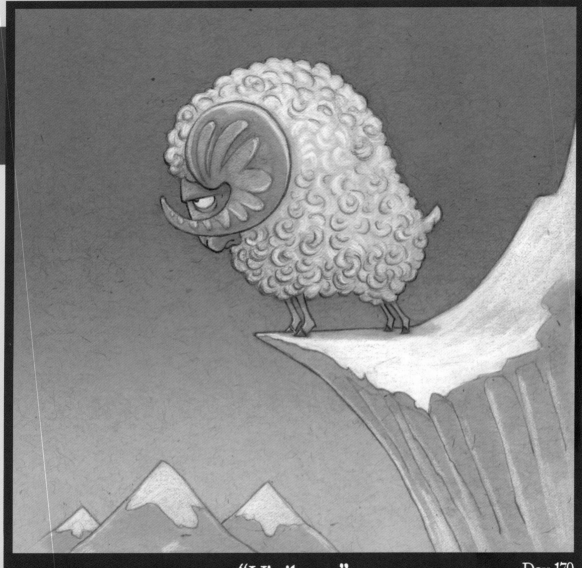

"Vigilance" Day 179

september 06

From my diagnosis to hospitalization, everything happened so fast. The thought that I just had a sore throat which stubbornly refused to go away was being violently replaced with the knowledge that my body was being invaded by a potentially fatal cancer. Understandably, it left me reeling.

Fortunately, I was in very capable hands. Dr. Gary Schiller and the UCLA team were extremely vigilant and attentive to detail. Dr. Schiller was knowledgeable, committed, compassionate, and humored me by laughing at my bad cancer jokes which he had probably heard many times before. He even stopped by on his way to a Memorial Day picnic, his wife and son waiting in the car, to check on me and his other patients. The nursing staff kept a close watch on me around the clock, administering medications, taking vitals, encouraging me to take a few laps up and down the hallway if I felt up to it, and overall making me feel as "safe" and comfortable as possible.

The support and sense of camaraderie extended beyond the medical staff. There was Frini, the social worker who made all the paperwork and time-sensitive sperm-banking possible and Maria, the housekeeper who came in every day to mop my floor to keep my room as germ-free as possible, always greeting me with a smile and some positive words. I had some enlightening discussions with Michael, a chaplain, and there was the food services guy who brought not only my dinner but also a small lift to my spirits by always saying, "Here you go, chief!"

The UCLA team members, from transplant coordinators to case managers to echocardiogram techs to volunteers to admissions staff, were all very helpful and supportive. They made me feel like I was not in this alone but rather the star rookie on a team of experienced veterans, ready to gang tackle this cancer beast.

DAY 160 ▲

Snack Time?

Despite the apparent odds, my money's on the bunny.

Sssssstorytime

Bat

Bats are fascinating creatures. There are approximately 1,100 species, with wingspans ranging in size from six inches (the bumblebee bat of Thailand) to six feet (the Malayan flying fox). Some of these pest-control pros can consume up to 1,200 insects per hour. During echolocation, the "radar" used to search for prey, some bats emit sound waves from their mouths while some do it from their noses.

DAY 174 ▲

Evil Fuzzy Bunny

DAY 175 ▶

Serval

Servals have unusually long necks and legs; hence the nickname "giraffe cats." These features provide them a better view in the tall grasses of their natural habitat, mainly the savannas of sub-Saharan Africa, where they hunt small rodents, reptiles, and amphibians. They have also been known to snatch birds out of the air in mid-flight. Their large ears provide them with some of the best hearing in the cat family, and in proportion to their body, they have the longest legs of any feline.

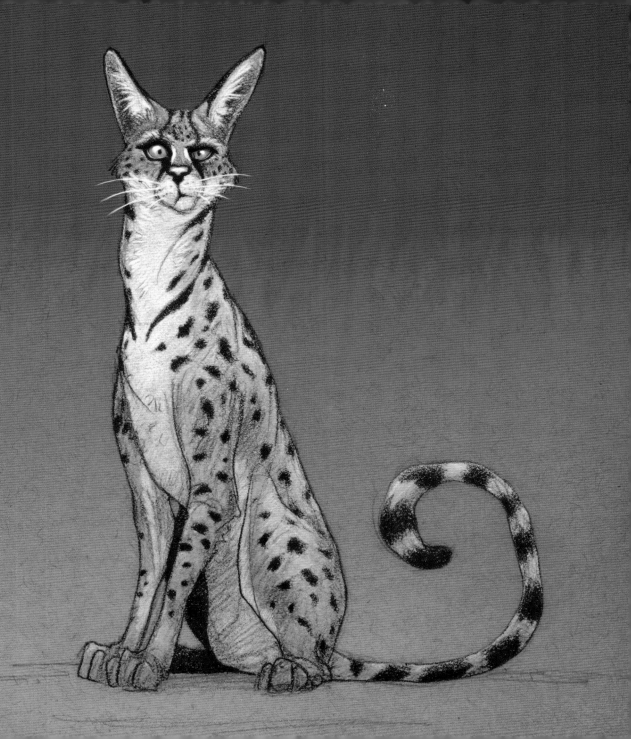

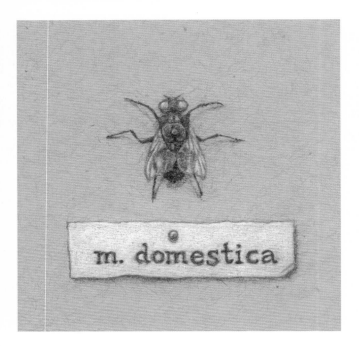

m. domestica

DAY 180

Common House Fly

No flies were harmed in the creation of this drawing.

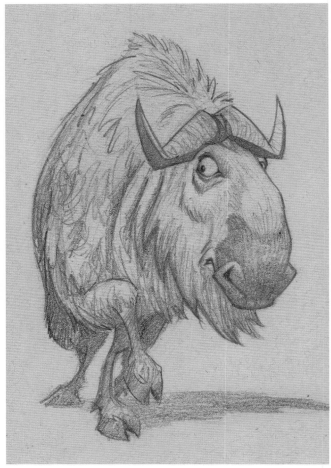

DAY 181 ▶▲

Takin

Takins are endangered goat-like creatures native to mountainous regions in Asia. It is thought that the yellowish color of their coats provided the inspiration for the Golden Fleece sought by Jason and the Argonauts in Greek mythology.

DAY 182 ▶

Takin, Take Two

Like the pair of rhinocerotids shown earlier, this is an example of slightly caricaturing a subject one day and then pushing it even further into the cartoon realm the next.

"Insecure Traveling Salesmonkey" Day 192

october 06

Filling the blank pages of *The Daily Zoo* one by one is how I try to live my life in general: one day at a time. I like that I only have to "worry" about or concentrate on today's animal. I only have to fill one page. This was especially brought to my attention during my long hospital stays and recovery period. If I dwelled too much on the remaining rounds of treatment and their associated ills and unpleasantries, or on the many months of recovery before I regained my strength, it seemed overwhelming. But if I could just focus on getting through today, these next 24 hours, it was usually an easier pill to swallow.

The concept of "tomorrow" can be both laden with the fear of the unknown and a powerful vessel for hope. I try to keep myself in the moment - tomorrow will be here soon enough and is usually wide open for possibilities. As long as there is another day, another blank page in life's sketchbook, there is the possibility that something wonderful will occur.

DAY 185 ▲

Furry Tree Dweller

My initial plan was to do an exotic, perhaps extra-terrestrial, possum-like mammal, but I got distracted because I was at a bar watching my beloved Green Bay Packers fall to the Philadelphia Eagles. The resulting sketch was not creatively "pushed" nearly as much as I had intended. I find that energy and focus are two main ingredients of a successful drawing. They don't guarantee success, and success can even occur without them at times, but being present and concentrating greatly increases the chances that the drawing will turn out better.

DAY 186 ▼

Alien Possum

On the following day I wanted to take another crack at an exotic arboreal critter. This time, no football.

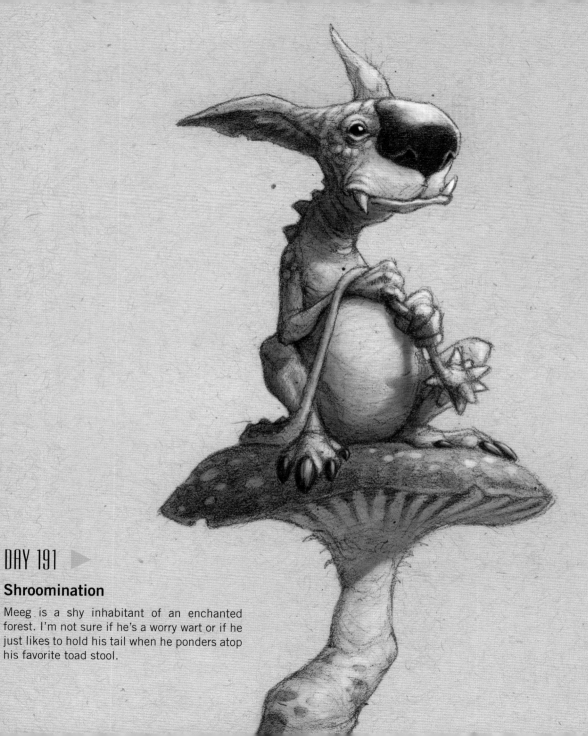

DAY 191 ▶

Shroomination

Meeg is a shy inhabitant of an enchanted forest. I'm not sure if he's a worry wart or if he just likes to hold his tail when he ponders atop his favorite toad stool.

DAY 200 ▶

Wizard Lizard

Sometimes an idea for a character will start off with words rather than visuals. This reptilian sorcerer started off as a play on the similar-sounding words "wizard" and "lizard." Plus it was just fun to say. (In hindsight I should have drawn him in a blizzard...with a gizzard...)

DAY 193 ▲

Hover Bug

This extra-terrestrial insect was done on my lunch break while working at Amalgamated Dynamics, Inc. I was doing concept design for the film *Aliens vs. Predator: Requiem* and it was my first big project since the leukemia. I started off working just a few days a week and slowly added more as my strength and endurance increased. It was another important milestone in getting back to "normal" life.

DAY 199 ▶

Thorny Devil

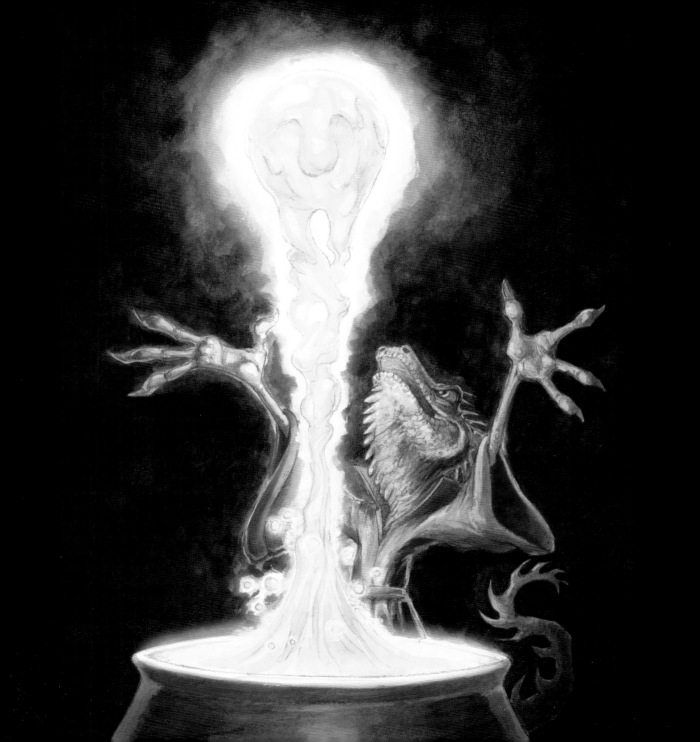

DAY 205 ▽

'Possum in a Pumpkin

This was done after having some friends over to carve pumpkins.

DAY 209 ▷

Bongo

Bongos are large, forest-dwelling African antelope. My original intention was to stylize the bongo (such as the ultra-thin legs) but I didn't follow through on that because I think I got caught up more in the actual application of paint rather than focusing on what I was painting. In the safe confines of a sketchbook this is fine, but if this were for a client I would have to make some changes.

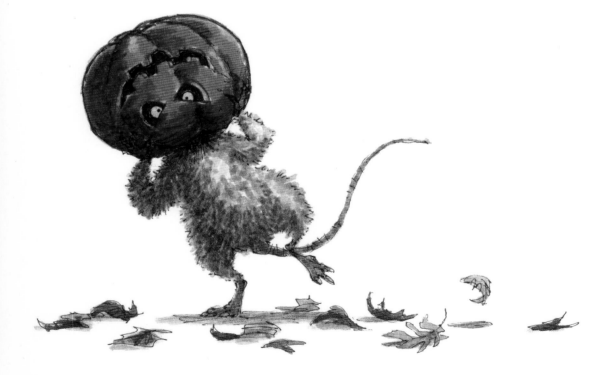

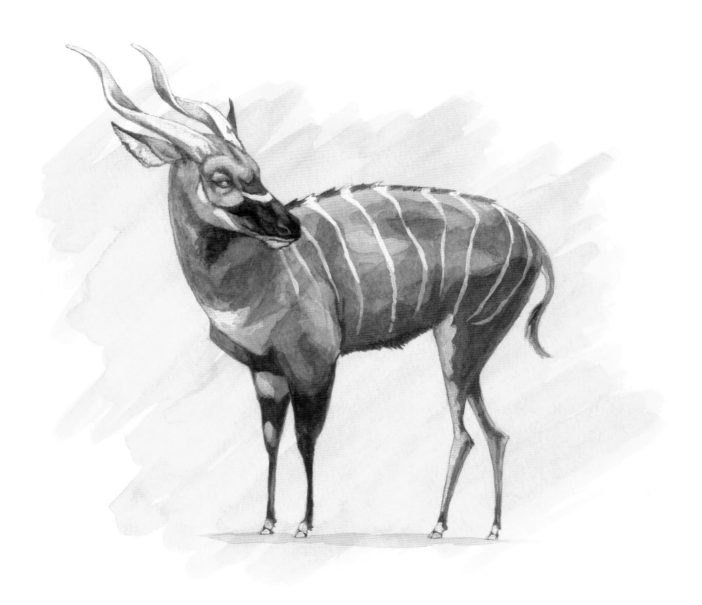

DAY 211 ▲ Not what I'd want to encounter while paddling along in my lava-proof kayak.

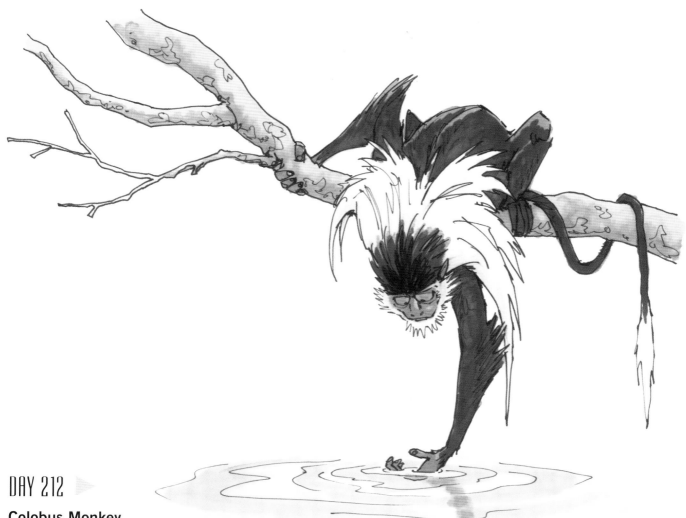

DAY 212 ▶

Colobus Monkey

Seeing your artwork through the eyes of others can give you new perspectives. When I've shown people *The Daily Zoo* sketchbooks, it has been interesting to see which drawings certain people react to. This one, for example, was a favorite of a woman I met while waiting at an airport gate. Everyone responds more favorably to different ones, possibly as a result of individual personality and life experience.

DAY 213 ▶

Sorry Kid, You Ain't Nuthin' But A...

One of the benefits of doing *The Daily Zoo* was that it put a pencil in my hand *every* day and forced me to draw (a task I usually relished). Practice! Practice! Practice! The only way I can hope to aspire to improve as an artist is to seek new challenges, observe, learn, and *lots* and *lots* of practice.

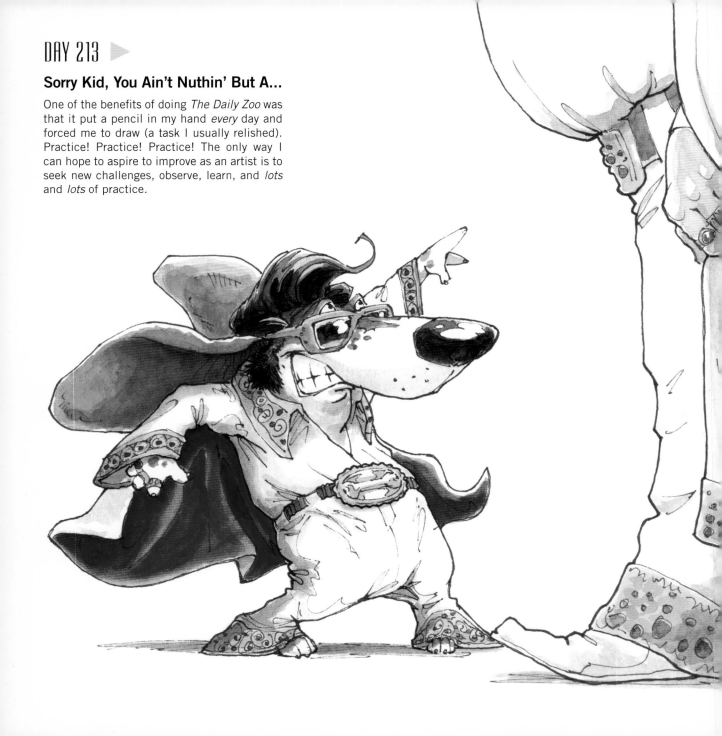

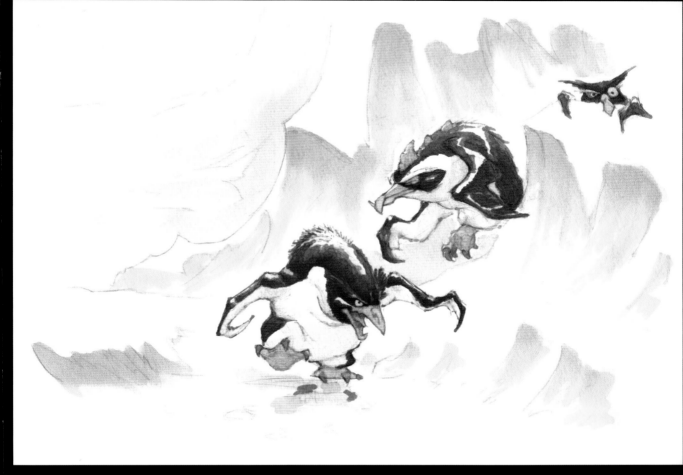

DAY 214

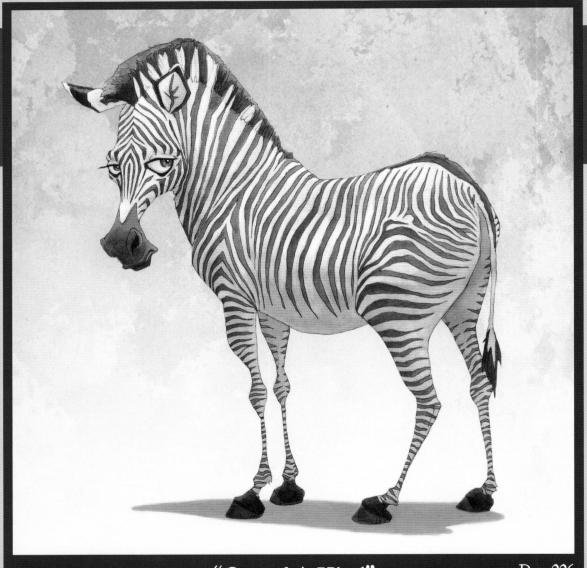

"One of A Kind" Day 226

november 06

No two zebras share the exact same set of stripes. Likewise, no two cancer patients are exactly alike – not even two acute myelogenous leukemia patients. Each patient has a genetic background, medical history, and life experience that are unique to him or her. That can be a helpful thing to remember when you, as a cancer patient, inevitably encounter the dreaded "Statistics": survival rates, morbidity rates, sterility rates...broken down by race, age, gender, eyelash length...

I had just finished my first round of chemo and was feeling pretty positive about the direction that things were heading when my oncologist rattled off a bunch of foreboding stats and possible outcomes and scenarios. Five-year survival rates for AML were approximately 40%. Because of the high toxicity of the drugs that were *healing* me, I'm at a much greater risk for developing secondary cancers down the road and there is a good chance that I will have a shorter lifespan overall. What little bubble of hope I had burst instantly. But he was only doing his job, and a good doctor *will* inform you of the stats. They are important to hear once to give you some sense of the magnitude of what you're dealing with, but then they should be quickly ushered to the furthest recesses of your mind. There is no point in dwelling on them and it is important to remember that they are just faceless numbers. Stats are just stats. I believe they are more meaningful to the doctors and scientists working with the diseases than to the people who are experiencing them firsthand.

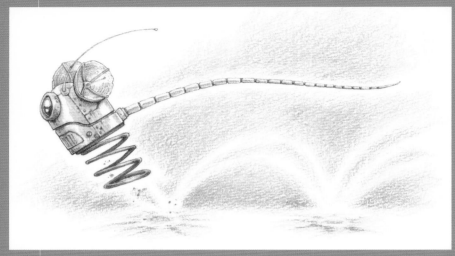

DAY 219 ▼

Hippo

Based on a photo taken at the Los Angeles Zoo, this was done to try to increase my comfort level with using gouache. I also wanted to paint an animal with some dramatic lighting in an attempt to improve the depiction of light in my work.

DAY 224 ▲

Newt Neon to the Rescue!

Newt Neon is a super-powered amphibious crime fighter whose civilian alter ego cannot be divulged at this time.

DAY 229 ▶

Stork Chap

This is another example of starting out with a vague notion or feeling of a character rather than a clear idea. I envisioned him as a proper ol' professor-chap-stork-guy-sort-of-thing and let the details evolve as the sketch progressed.

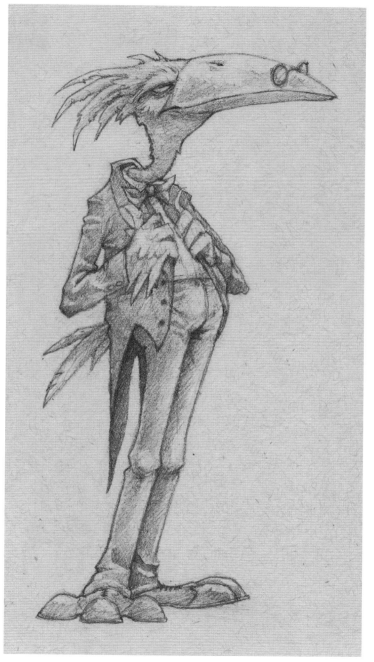

DAY 239 ▷

Serpentine Jester

I thought the kinky bends and bright colors of this guy's body made him a good candidate to serve as a court jester.

DAY 237 ▽

Her Heaviness

After seeing *Happy Feet*, a film about animated penguins, Thasja requested an "elephant seal princess on the back of a penguin." I wasn't about to be so cruel as to subject a single penguin to carrying an ELEPHANT SEAL on his back, so I gave him some help.

DAY 235 ▲

Toad Hostile

Your average garden toad gone bad.

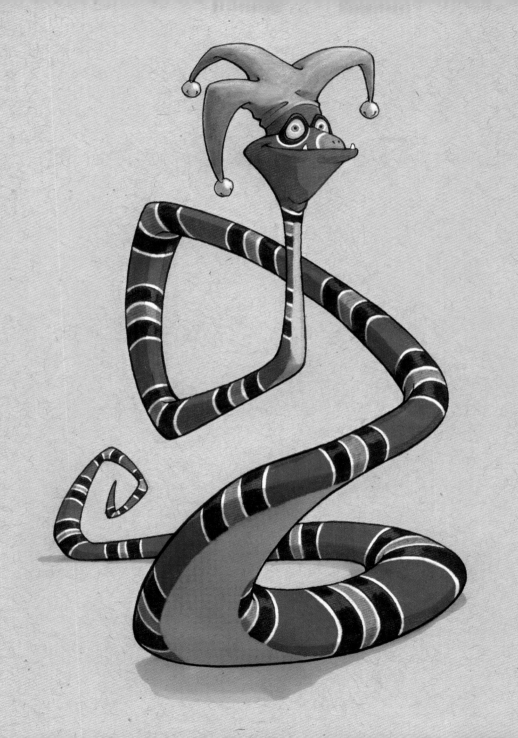

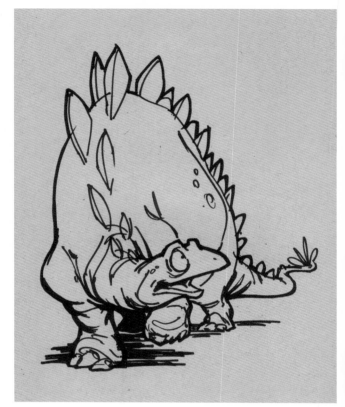

DAY 241 ◀

Grasshopper

DAY 242 ▲

Stegosaurus

This dino was drawn in a matter of minutes using just a Sharpie pen. I did no preliminary pencil sketch but felt instead like just winging it. Sometimes I enjoy the challenge of drawing with a permanent medium. It forces me to either think carefully about a line before I draw it or to draw quickly and be open to the results, whatever they may be.

DAY 243 ▷

Cannonball or Swan Dive?

The determination of this beaver about to take a plunge took me back to my many hospital stays. I underwent numerous tests and procedures – none of which I would have called fun, but I really had no choice.

"You need to poke me with that large needle *where*?"

"You need me to slowly drink *what*?"

"You need to extract how much of *what*?"

Each time I took the plunge and tried to make the best of it.

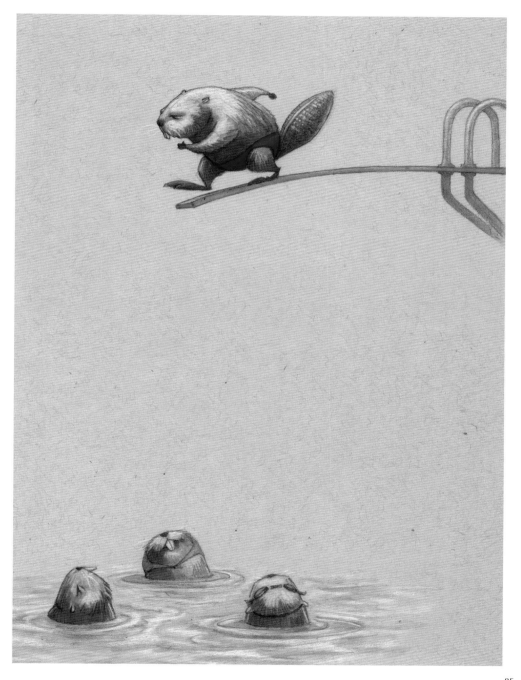

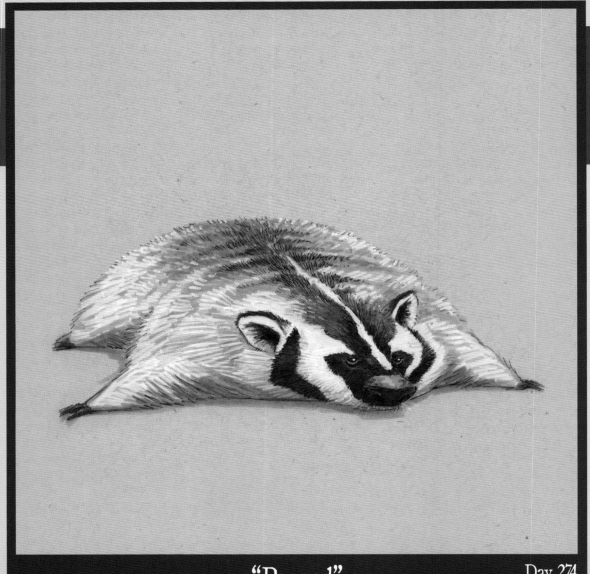

"Pooped" Day 274

december 06

One of the symptoms of leukemia, and also a side effect of the treatment, is fatigue. And when I say fatigue I mean complete-and-utter-down-to-the-very-core-of-your-being-physical-exhaustion. It's like your individual cells have all run back-to-back-to-back marathons in different directions and cannot fathom the slightest notion of taking one more step. In the years prior to my diagnosis, I had periodically worn myself out working hard on school or freelance projects, with frequent all-nighters as deadlines or the semester's end approached. But this was *nothing* compared to "leukemia exhaustion." Upon returning home a month after my stem cell transplant, I could not walk more than fifteen feet without needing to sit down and rest. Added to this was the mental and emotional exhaustion from the whole cancer experience. I was beat. I was *pooped*.

My recovery was a long and unsteady process. There were days that I felt more tired and weak than the day before and it seemed that I had taken a step backward. But overall, my strength and stamina slowly returned. When I started *The Daily Zoo*, I was fairly close to my pre-cancer energy levels. Still, as is the case with anyone, the amount of time and energy I had available on any given day varied. Some days are just busier and more hectic than others. This is reflected in the varying levels of "finish" of the sketches in *The Daily Zoo*. Some are monochromatic. Some have a splash of color. Some are meticulously rendered while others are simply the result of a five-minute flurry of pencil strokes, depending on the amount of time and energy I was able to devote to them. If I was feeling tired or uninspired, instead of *not* doing it, I would just go with the flow and simply give what I had to give on that particular day.

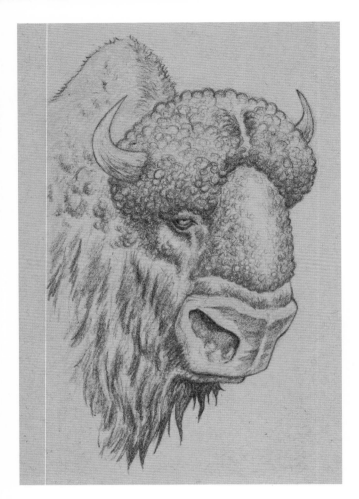

DAY 246 ▲

Bison

DAY 253 ▼

Ice Mole

Originally I was envisioning this character as an alien running to defend his space station from attacking intruders. But the more I looked at him, the more he seemed too relaxed for that, even enjoying himself as though he were gliding. That made me change directions, add the ice skates, and morph him from a space mole into an ice mole.

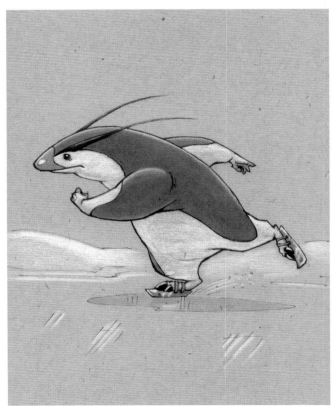

DAY 251 ▶

Count Moocula

This was an impulsive drawing. I had a quick idea flash through my head – "vampire cow" – and just ran with it.

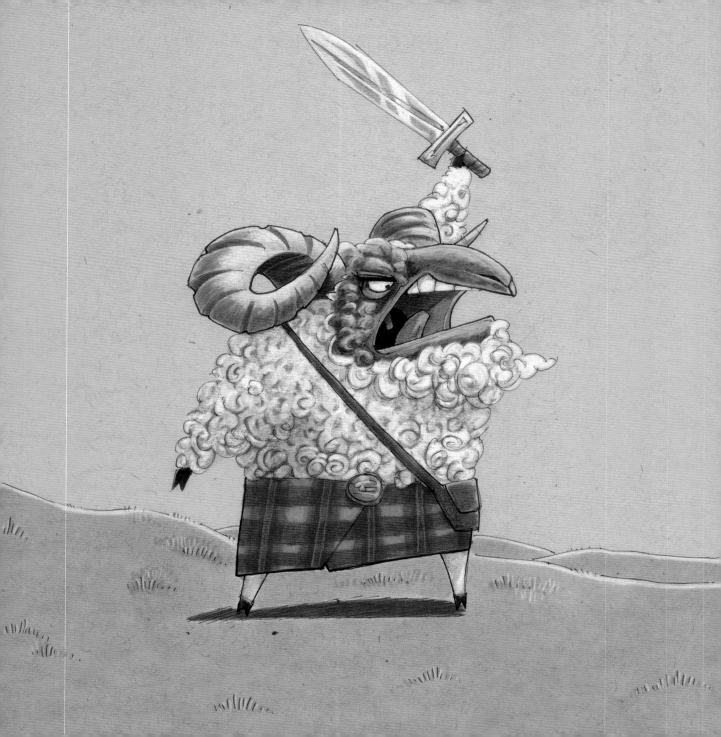

DAY 255

Freedom!

After many rounds of fierce auditions, Ewen "Shags" MacCurlin finally won the coveted lead role in the Woolshire County All-Livestock Theatrical Company's production of *Braveheart.*

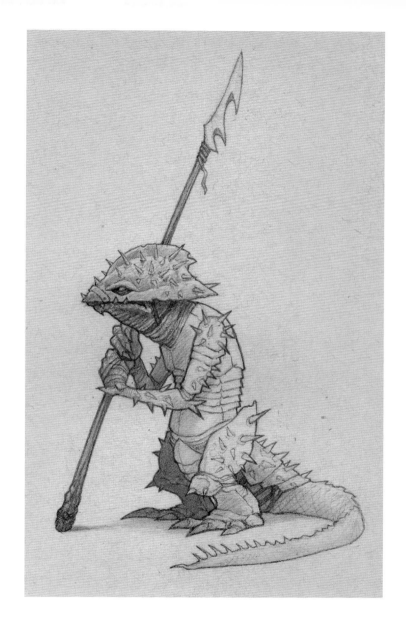

DAY 259 ▷

Reptilian Guard

There are many artists I find inspirational. Among them are Brian and Wendy Froud, whose work on such films as *The Dark Crystal* and *Labyrinth* were visual candy to my artistic sweet tooth as a child. Their creations were probably lingering in the back of my mind as I drew this iguanaesque infantryman in the Reptilian Guard.

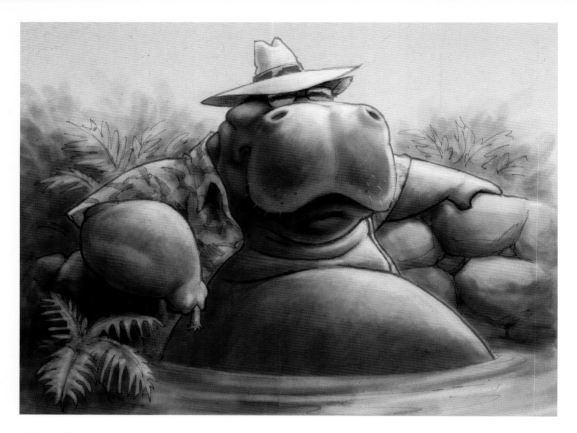

DAY 267 ▲

Hippoescobaramus

While I was home for Christmas in Minneapolis, I read a newspaper article that inspired the day's sketch. It was about the abandoned estate of the late Colombian drug lord, Pablo Escobar. After Escobar was gunned down while on the run in 1993, his compound, which included a private zoo, fell into ruin. Most of the animals were relocated to other zoos or escaped into the surrounding jungle, but a small bloat of hippos (yes, that's what a group of hippos is called) not only survived but thrived, at least quadrupling their numbers in subsequent years. The Colombian government has offered them free for the taking, but because of the great expense and danger involved in their capture and transport, they have had no takers. For the most part, the people in the surrounding villages have adopted their multi-ton neighbors as community mascots and a symbol of civic pride.

DAY 269 ▶

Stinky Santa

This odiferous well-wisher was done on Christmas Day at grandmother's house in Wisconsin (which makes it literally over the river and through the woods). I used it as my 2007 holiday card. What joyous words of goodwill were inside? "Hope your holidays don't stink."

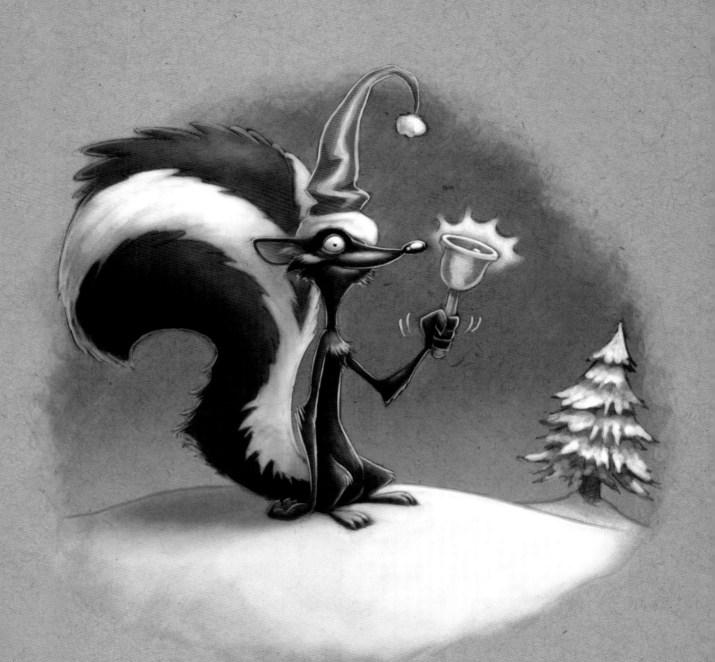

"Burning Bright" Day 276

january 07

"Tiger, tiger, burning bright
 In the forests of the night…"

Those opening lines to William Blake's poem *The Tiger*, which I remember from grade school, bring to mind the many family members and friends who came to my side during my cancer journey. Without being asked they rallied around me, showered me with love, and most importantly let me know that I was damn sure not alone in this ordeal. Their cards, visits, gifts, phone calls, and messages of good will were nice surprises that provided a welcome distraction from the not-so-nice surprises such as, "We need to perform a spinal tap on you this morning." They were my army, my striped legion of courage and ferocity, hearts and souls burning bright, doing their best to light the deep recesses of the dark and foreboding forest we were being forced to traverse. Who wouldn't feel a bit safer when surrounded by an army of tigers? The love of family and friends is truly some of the best medicine.

DAY 277 ▲

Long-nose Gar

DAY 285 ▶

Secretary Bird

After searching high and low at many art stores for an opaque white marker, I finally struck gold at a scrapbook supply store. This was one of the first *Daily Zoo* sketches on which I tried it, loosely sketching forms in white and then fleshing out contours and details with a fine-tip pen and markers on top of that.

It is commonly thought that the secretary bird got its name because of the long feathers protruding from the back of its head, which look like the quill pens used by secretaries in days gone by.

DAY 286 ▶▶

Puffins

Drawing these puffins was quite the challenge. They have such a graphic, stylized look to begin with that trying to push the forms or caricature them while still retaining their "puffin essence" proved to be a difficult task.

DAY 288 ◀

Saggy Undunt

Elephants are fun to draw because they have so many iconic parts (trunk, tusks, fan-like ears, bulky bodies, tree-trunk legs, saggy skin) that can be taken in so many different directions. Or perhaps I'm just subconsciously influenced by my fiancée's ever-growing elephant collection. "Undunt" was one of my early words as a kid.

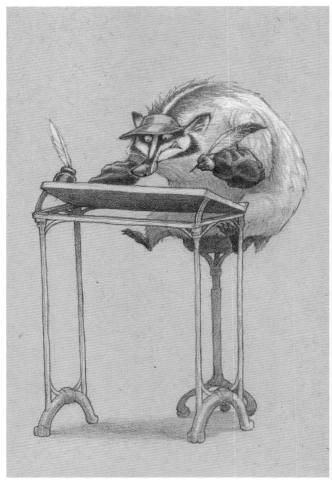

DAY 292 ▶

Badger Scribe

This badger was inspired by seeing a production of *The Christmas Carol* over the holidays and was done in the waiting room of the UCLA clinic during one of my monthly check-ups with my oncologist. I didn't mind these follow-up visits partly because they usually provided some quality *Daily Zoo* time but mainly because, believe it or not, it was a *good* feeling to go to the doctor. Returning to the UCLA medical campus was a poignant reminder to me of the many times I had made that journey while feeling completely fatigued, sick, bald, thin, weak, and with a tube sprouting from my chest. As my recovery progressed and I started to feel stronger and stronger, I felt ten feet tall retracing those steps.

DAY 294 ▶
Steamed

DAY 302 ▶

Eye to Eye
You and I are basically the same
Though we may each answer to a different name
No reason we can't see eye to eye
If all we do is simply try.

DAY 305 ▼

Bumbleblimp

DAY 295 ▲

Armadillo

"Scared Sheepless" Day 312

february 07

Cancer is scary – very, very scary. At various stages of my leukemia experience I was forced to confront my mortality in a way I had never done before. I had to think about death as a very real and immediate possibility, not just an abstract concept that will happen *some*day. My mind was also overloaded with questions, some very serious, others extremely trivial. How bad will the side effects from the chemo be? Even if the treatments are successful, will I suffer a relapse? Should I have an autologous transplant or an allogeneic transplant? Will the treatments make me sterile? What about a living will? How will I look *bald?*

How did I combat those fears? I asked my doctors, nurses, and other hospital support staff a lot of those questions. I talked about my fears and con-cerns with my fiancée, family, and friends. And I embraced humor, which can be such a powerful weapon. I tried to find the absurd, insane, and funny aspects in an otherwise very tense situation. I made a Pros & Cons list about having leukemia which happened to be much longer on the Pros side. For example, Pros: "Hairy ass no more!" and "More TV channels and better reception than at home" while one of the few cons was "Must endure the wrath of Shari for missing her 30th birthday." Plus, offering visitors some of my home-brewed "lemonade" from my portable urinal jug never got old – not to me at least. Once in a while the tears would flow and the fear would shake me to the core, but then I would try my best to get back to focusing intensely on the positive: "I want to *beat* this."

DAY 310

Saki with Sake

I cannot stress enough the importance of having good reference material. I clip interesting photos from magazines, scour libraries and the Internet, and my poor bookshelves sag under the weight of books on a wide variety of topics. Likewise, it is very important to be able to draw without reference material, using strictly your imagination. I find this especially true in the entertainment field where I am often asked to create things that do not exist.

In the case of this image, I knew what a white-faced saki was – a South American monkey with long black fur except for creamy white fur encircling its face – and if shown a picture of one I could identify it as such, but when it came to actually drawing one, I needed to consult some reference material to get the details right.

DAY 311

Storkoise

Obviously, this sketch is drawn completely from imagination (though if you have seen a real storkoise walking around, please contact me – I want to know *where!*) but it draws upon years of previous observation of reference material to lend it some small dose of believability, even in its cartoon state.

DAY 323

Phantastic Phil

Shari, a friend visiting from out of town, requested a flying squirrel when we met for lunch. I'm not sure this is what she had in mind.

DAY 329

Beware the Cruel Croll

At night the croll creeps out from his lair deep in the forest and preys on naughty children. I realize it's a bit of a cliché, but do you really want to tell *him* that?

DAY 318

Spiny Fish

Somehow I get the feeling that this fish is either too cunning or too tough to end up on someone's dinner plate tonight.

DAY 330 ◄

Koala

For some unknown reason, I loaded up on Australian fauna during the last two months of *The Daily Zoo*, using them as subject matter on twelve days (kangaroo, two kookaburras, koala, echidna, cassowary, goanna, two Tasmanian devils, weedy sea dragon, frilled lizard, and quoll). Each continent has its own unique wildlife "persona" but I find Australia's contribution to the animal kingdom particularly fascinating.

DAY 332 ►

Echidna

Echidnas, or spiny anteaters, are another resident of Australia and, along with the platypus, the only two mammals that lay eggs.

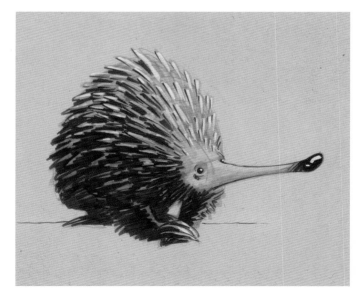

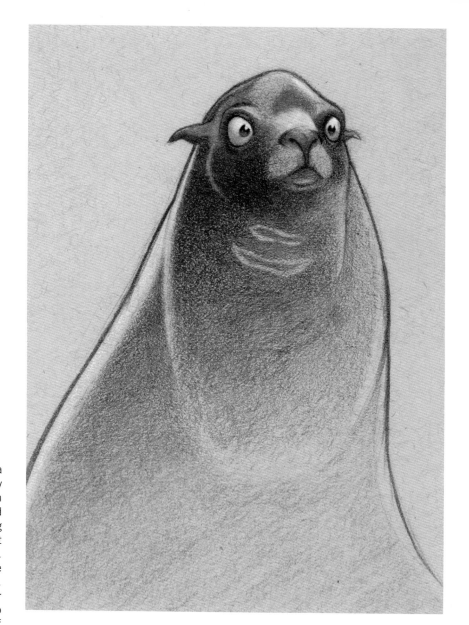

DAY 334 ▶

Sea Lion

Bald, wet, and cold – just like this sea lion. That's how I felt at times during my cancer months: bald, wet with feverish sweat and other bodily fluids, and cold from chills and laying on a frigid cooling blanket...except that sea lions aren't really bald, they just have very short fur... and they don't really feel wet because they're so streamlined and waterproof... and they don't really feel the cold either because of thick layers of blubber...so there goes that comparison. I wonder if my cancer experience would have been more pleasant had I been a sea lion?

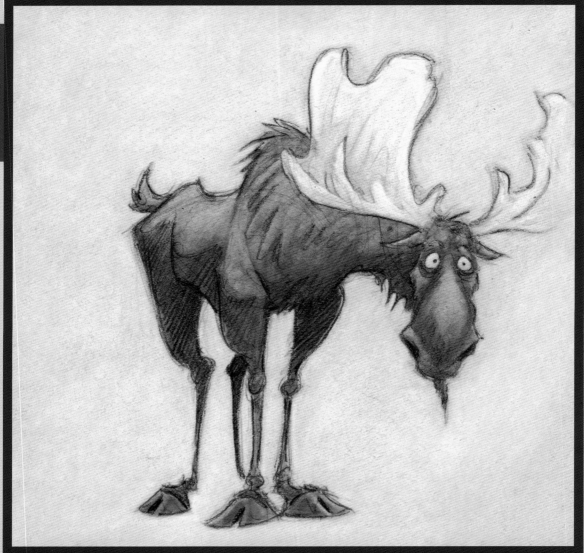

"Wilbur Slowly Realizes He Forgot Where He Parked" Day 344

march 07

At the time of drawing this moose, Alaska was on my mind as Thasja was deep into training for her first-ever marathon, the annual Mayor's Marathon in Anchorage. She was training with the Leukemia and Lymphoma Society's Team in Training program which combines physical training with fundraising for blood cancer research and patient services. Like many of her fellow trainees, her decision to participate was a direct result of an intimate encounter with cancer. Throughout her marathon experience she met many wonderful people and heard many inspirational stories. On the day of the race it was quite a sight to behold an almost continuous stream of purple Team in Training jerseys racing past amongst the other runners, many carrying their own stories about either experiencing cancer themselves or through the eyes of another. Thasja felt honored to be a part of that.

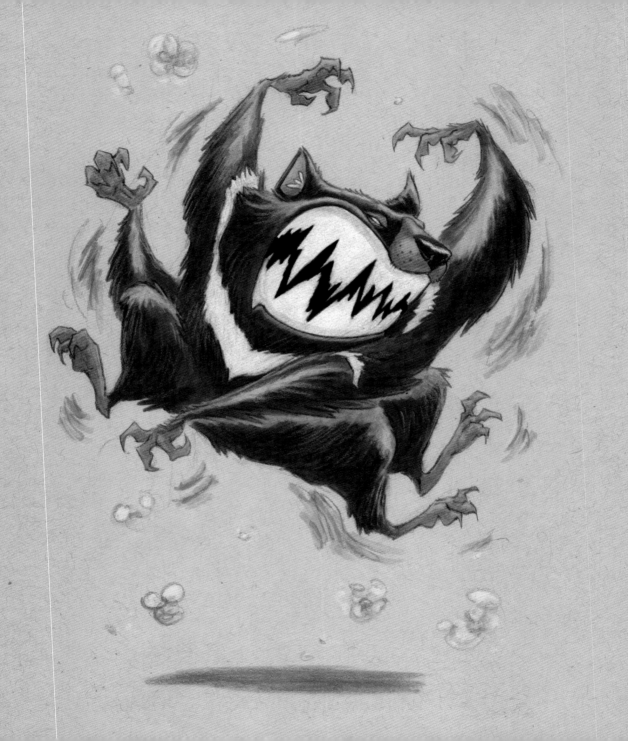

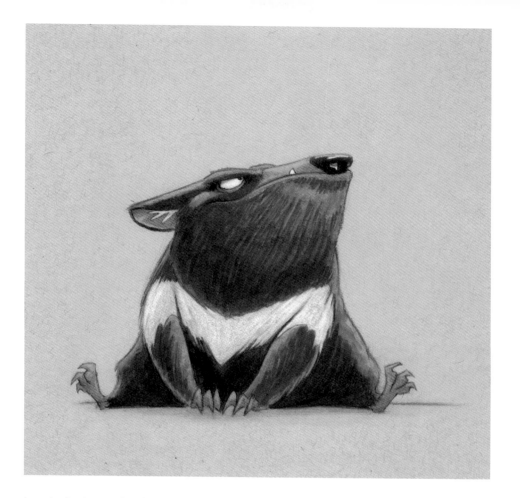

Tasmanian Devils

On Day 341 I drew a Tasmanian devil showcasing its reputation as a fierce and vicious little marsupial. The following day I thought it might be fun to go against that stereotype and explore the calmer and more contemplative side of the "beast."

While it was not a conscious intention while drawing them, these two sketches provide a nice metaphor for coping with cancer or, in a broader sense, life. Shortly after moving to Los Angeles years ago, my friend Trish introduced me to yoga and I soon became a fan. As we would be balancing on one leg, our other limbs stretching in various directions, the instructor would say, "You're going to find yourself in

difficult situations – this is LA after all. But how will you choose to react? Will you freak out and get stressed or will you remain calm and focused?"

Breathing is a big part of yoga...and life. It's a simple thing that you don't think about most of the time, and it can easily be forgotten when things get tense. *In... Out*...Remember to breathe. I breathed *a lot* in the hospital. It helped during the biopsies, mouth sores, and many sleepless nights as I pondered the fact that I had cancer. *In...Out*...It provided something mundane and simple to focus on when my head was filled with so many overwhelming thoughts. *In...Out....*

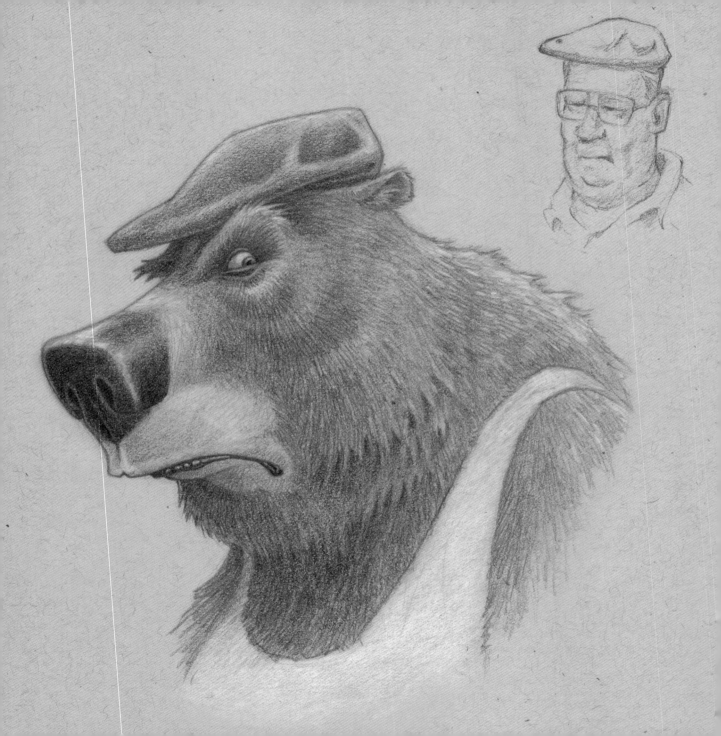

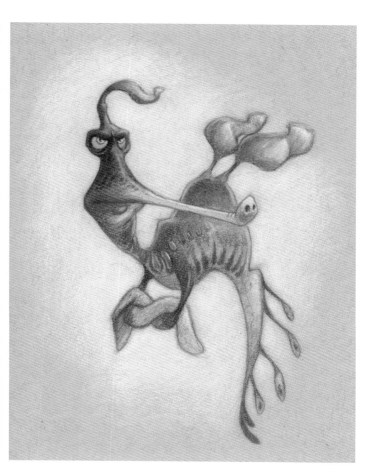

Lenny the Weedy Sea Dragon

Weedy sea dragons are close relatives of the seahorse and are only found off the coast of Australia. Lenny is usually quite pleasant to be around, but on this particular day he woke up on the wrong side of the reef. Many cartoon characters are depicted as always happy and cheerful. The best ones, however, have a range of emotions and moods just like their intended audience: happy, sad, angry, shy, agitated, surprised.... *Sesame Street's* Oscar the Grouch is a phenomenally honest character. Everyone has bad days and crabby moods sometimes.

Most of the time during my cancer experience I tried to be positive and focus on the many good things that were happening, like a "thinking of you" card arriving from a close friend or my daily phone calls from my sister and parents. As bad as the leukemia treatments were and as repetitive as the hospital menu was, I tried to be thankful that I wasn't experiencing even graver complications from my chemo cocktail and that the food was actually pretty decent. But some days, you just don't have the strength and energy for that. You strive for being positive and upbeat, but once in a while (especially for cancer patients!) it's okay to be a Grouch.

DAY 348

Waiting Room Bear

This was another entry done in the waiting room of the UCLA clinic. I often had ample drawing time during these visits since I would have my blood drawn and then usually have to wait about an hour until the results were back before seeing my oncologist. In this case I was sitting across the room from a big bear of a man who inspired the sketch of the day.

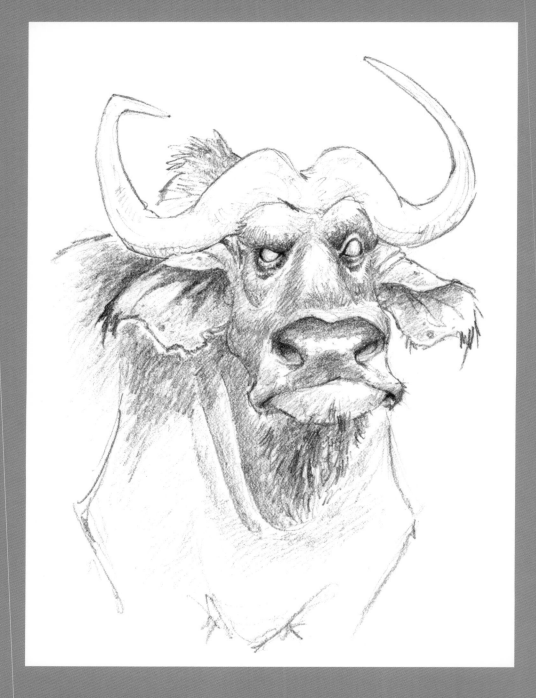

DAY 354

African Buffalo

The Daily Zoo left...forgotten...abandoned! I left the sketchbook at work one day, so I had to do the sketches for the next two days on separate sheets of paper and glue them in once the 'official' *DZ* sketchbook was safely retrieved. I felt like a bad parent.

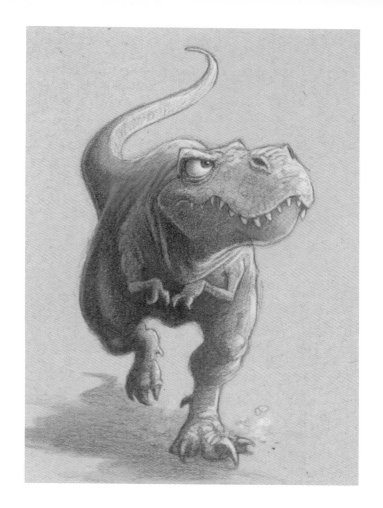

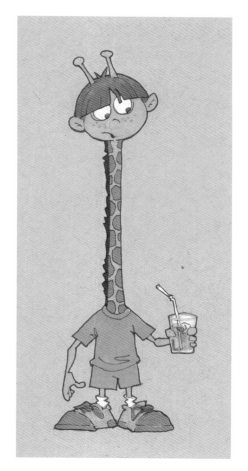

DAY 359

Christopher Giraffe

A few years ago my sister rediscovered a cassette tape of our dad interviewing us as kids. At one point my dad asked me, "What's your name?"
"Christopher," I replied in my five-year-old voice.
"Christopher what?" he inquired further.
"Chrisssstoooopheeerrrr...giraffe!" And my sister has called me that ever since. (And yes, I did have a pair of bright red and yellow sneakers as a kid. They were the coolest.)

DAY 363

T-rex

DAY 365 ▶

Finished at the Finish

I made it. One year. An animal a day. I wouldn't be able to rest too long, however, as *The Daily Zoo: Volume Two* was waiting the following day with yet another blank page, ripe with possibilities....

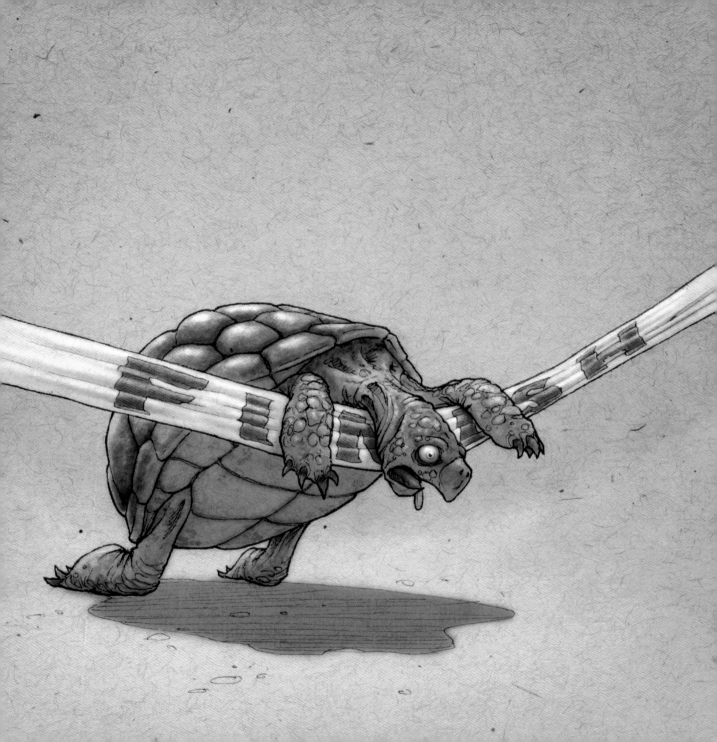

Volume One of *The Daily Zoo* consumed six sketchbooks of various shapes and sizes.

oink.

the daily zoo

Volume One:
Year in Review

Looking back on all 365 sketches I think there were some hits, a lot of misses, but all provided a positive experience. It was more about the process than the result. Public response and artistic results can be unpredictable at best, so if you're going to do it, you had better *enjoy* doing it.

2

3

4

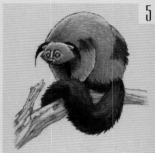

5

Hammerhead Sharks DAY 002
"Mr. & Mrs. Hammer at the Opera"
House-sitting at Judith's

Grizzly DAY 003
Home

Mountain Goat DAY 004
Mar Vista Library

Binturong DAY 005
Venice Grind Coffee Shop

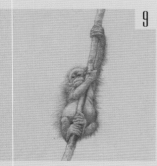

9

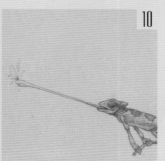

10

11

12

Baby Orangutan DAY 009
Based on a photo by Mitsuaki Iwago.
House-sitting at Judith's

Chameleon DAY 010
"Gotcha!"
Home

Cardinal DAY 011
"Drop of Cardinal"
Mar Vista Library

Penguin DAY 012
"The Penguin Who Made My Day"
Venice Grind Coffee Shop

T F S

1

Blue-Footed Booby DAY 001
House-sitting at Judith's

6

Dinosaur DAY 006
Mar Vista Library

7

Hippopotamus DAY 007
"Rita"
Home

8

Armadillo DAY 008
My favorite animal as a kid.
House-sitting at Judith's

13

Raccoon DAY 013
Scribble Exercise
House-sitting at Judith's

14

Komodo DAY 014
"Konstable Komodo"
Home

15

Toad DAY 015
Requested by Thasja; my first time
using a colored pencil stick.
Home

Black Bear DAY 016
Grab bag: "Black Bear" and "Croquet"
Home

Baboon Studies DAY 017
Trying various levels of caricature with
the same subject matter.
Mar Vista Library

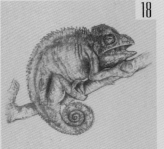

Chameleon DAY 018
Home

Tortoise DAY 019
Home

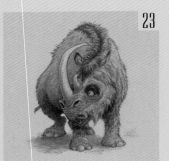

Rhinocerotid DAY 023
Home

Rhinocerotid DAY 024
Home

Toucan DAY 025
Character design for my children's book.
He must be a Green Bay Packer fan.
Northridge Mall Food Court

Polar Bear DAY 026
Home

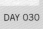

Flamingo DAY 030
"Flamingo Fu"
Home

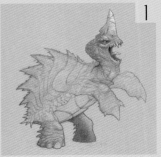

Monster Tortoise DAY 031
"Huantes Tortoisii"
Inspired by the art of Carlos Huante.
Home

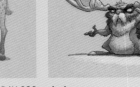

Hyena DAY 032
Home

Jackamoose DAY 033
"Jacques Jean-Pierre"
Character design for my childrens' book.
Home

T	F	S

20

Dragon DAY 020
Home

21

Hippopotamus DAY 021
"Lardo da Vinci"
This guy was named by my dad.
Venice Grind Coffee Shop & Home

22

Sperm Whale DAY 022
Home

27

Porcupine DAY 027
"Prickly Puffer"
Home

28

Alligator Salesman DAY 028
I wonder what he's selling?
Home

29

Gorilla DAY 029
Done entirely with colored brush pens.
Home

4

Hawk DAY 034
Home

5

Walrus Chef DAY 035
Home

6

Elephant DAY 036
"Echo"
Home

apr-
may
06

7

Walrus Chef No. 2 DAY 037
"Dammit Jim! I'm a chef not a doctor!"
Home

8

Pangolin DAY 038
Home

9

Furry Band Leader DAY 039
Scribble Exercise
Home

10

Zebra and Bumblefairies DAY 040
"Beware the Bumblefairies!"
Home

14

Mongoose DAY 044
"Come Out, Come Out, Wherever You Are"
Home

15

Warthog DAY 045
"Wilcox"
Manhattan Village Shopping Center,
Manhattan Beach

16

Satyr DAY 046
A half-human, half-goat creature from
Greek and Roman mythology.
Home

17

Rhinoceros & Butterfly DAY 047
"Face to Face"
Home

21

Caiman Studies DAY 051
Home

22

Crocodilians DAY 052
Home

23

Orangutan DAY 053
Scribble Exercise
Home

24

Skull Monster DAY 054
Inspired by an image of a black rhino-
ceros skull.
Home

T	F	S

11

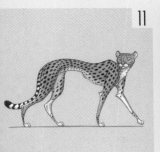

Cheetah DAY 041
Mar Vista Library

12

Dragon DAY 042
Home

13

Rabbit DAY 043
"Sex Bunny"
Requested by Thasja.
Home

18

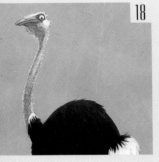

Ostrich DAY 048
Based on a photo taken at the LA Zoo.
Home

19

Armadillo DAY 049
"Don't Mess With Texas ('Dillos)"
Home

20

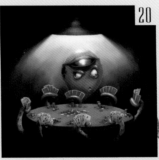

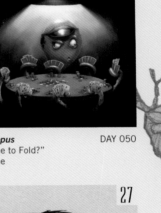

Octopus DAY 050
"Time to Fold?"
Home

25

Indri DAY 055
"Interstellar Iz"
Character design for my children's book.
Home

26

Indri DAY 056
More Iz studies.
Home

27

Crow DAY 057
Holiday Inn Express, 29 Palms, CA
(outside of Joshua Tree National Park)

28

Aardvark & Pangolin DAY 058
Holiday Inn Express, 29 Palms, CA
(outside of Joshua Tree National Park)

29

Wolverine DAY 059
Scribble Exercise; exhausted from hiking
& being stuck in Memorial Day traffic.
Home

30

Monkey Studies DAY 060
Clockwise from top left: Emperor Tamarin,
Cotton-top Tamarin, Uakari, Siamang.
Northridge Mall Food Court

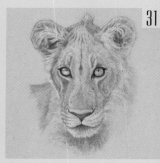

31

Lioness DAY 061
This one took 2 hours and 6 minutes.
Home

4

Peacock DAY 065
Home

5

Snail DAY 066
I was given crayons while I was in the
hospital so I had to put them to use!
Home

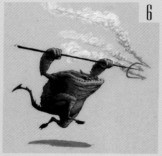

6

Demonic Imp DAY 067
ADI & Northridge Mall Food Court

7

Llama DAY 068
I was designing a llama puppet at ADI
so llamas were on my mind.
ADI lunch break

11

Zebra Studies DAY 072
Done with white correctional fluid and
brush pens.
Home

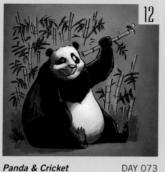

12

Panda & Cricket DAY 073
"Encounter"
Home

13

Pandas DAY 074
Wanted to take another crack (or two)
at that big black n' white furball.
Home

14

Nasty Insect DAY 075
I was really tired after work and quickly
lost interest in this one.
Northridge Mall Food Court

may-jun 06

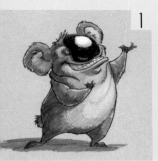

1

Koala
Home
DAY 062

2

Giraffe
Home
DAY 063

3

Nuclear Squirrel
Home
DAY 064

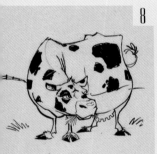

8

Cow
ADI & movie theater parking lot
DAY 069

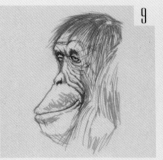

9

Orangutan
Done in my parked car in the Los Feliz neighborhood, killing time before meeting friends for dinner at Palermo.
DAY 070

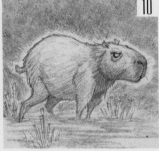

10

Capybara
He looks like a Fred to me for some reason.
Home
DAY 071

15

Babirusa
"Bamboo Bob"
Character designs for my children's book.
Northridge Mall Food Court
DAY 076

16

Gorilla (Posterior)
ADI lunch break
DAY 077

17

Gorilla
Home
DAY 078

18

Andean Condor DAY 079
Condors often excrete waste onto their legs
and feet to cool them through evaporation.
Home

19

Gecko DAY 080
Home

20

Chacoan Peccary DAY 081
Northridge Mall Food Court

21

Elephant DAY 082
Last page in the first *DZ* sketchbook.
Home

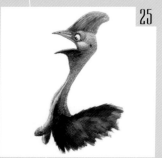

25

Cassowary DAY 086
Home

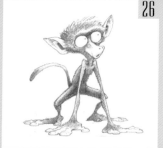

26

Baboon DAY 087
Home

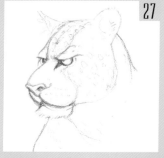

27

Jaguar DAY 088
Home

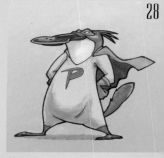

28

Platypus DAY 089
"Platypus Power"
Home

2

Mouse DAY 093
Scribble Exercise
Home

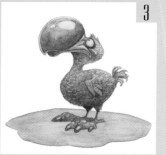

3

Dodo DAY 094
"The End?"
Home

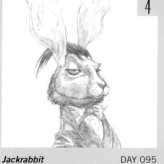

4

Jackrabbit DAY 095
"Rabbit. *Jack* Rabbit."
Home

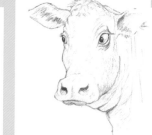

5

Cow DAY 096
ADI lunch break

T	F	S

22

pider DAY 083
equested by friend Sean.
ean's apartment

23

Snake DAY 084
Requested by friend Garth while driving
home from pillow fort construction.
Garth's car & Home

24

Lion DAY 085
"King of the Pillow Fort"
Pillow Fort, Anaheim hotel

jun-jul 06

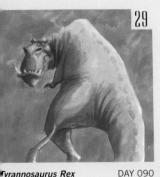

29

yrannosaurus Rex DAY 090
Painted in gouache.
Home

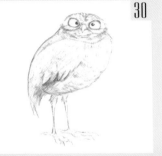

30

Burrowing Owl DAY 091
Lives in burrows underground and is one
of the few owls active during the day.
Home

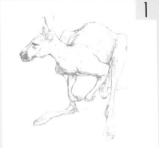

1

Kangaroo DAY 092
Home

6

Badger Biker DAY 097
Home

7

Rhino DAY 098
Hollywood, done in my car before a
20th anniversary presentation of *Aliens*
at the historic Egyptian Theatre.

8

Bertram Beaver at the Races DAY 099
"...and it's Aspen Quake by a nose!"
Home

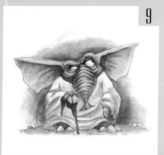

9

Yodaphant DAY 100
May the Farce be with you.
Home

10

Crab DAY 101
Home

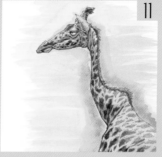

11

Giraffe DAY 102
Based on a photo taken at the LA Zoo
(with a little artistic license).
Home

12

White Ibis DAY 10.
Home

16

Minotaur DAY 107
Home

17

Proboscis Monkey DAY 108
This monkey gets its name from its
large nose (up to 7 inches in males).
Home

18

Proboscis Monkey DAY 109
"All Aboard!"
Northridge Mall Food Court

19

Tapir DAY 110
Drawn from life as Thasja surprised me
with a trip to the zoo for my birthday.
Los Angeles Zoo

23

Polychromatic Hippo DAY 114
Started in the car while coming back
from San Diego and finished at home.

24

Alligator Snapping Turtle DAY 115
"Bruiser"
Requested by friend Yuri.
Home

25

Warthog Pirate DAY 116
"The Golden Voyage of Swinebad?"
Northridge Mall Food Court

26

Goat DAY 117
Home

13

Mongolian Wild Horse DAY 104
lso called the Asian Wild Horse and
rzewalski's Wild Horse.
lome

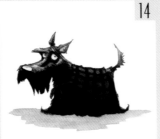

14

Scottie Dog DAY 105
Home

15

Carolina Wood Duck DAY 106
Home

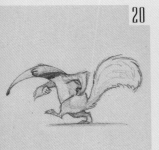

20

Anteater DAY 111
Home

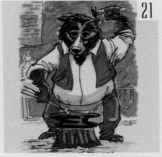

21

Bear DAY 112
"Burly Benjamin the Blacksmithing Bear"
Home

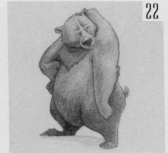

22

Bear DAY 113
Home

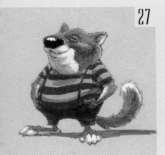

27

Blue Furry Thing DAY 118
Northridge Mall Food Court

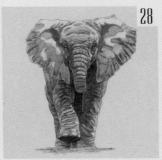

28

Elephant DAY 119
Based on a photo by Gerry Ellis.
Home

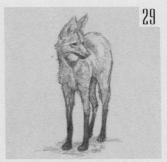

29

Maned Wolf DAY 120
Yes, their legs really are that long.
Home

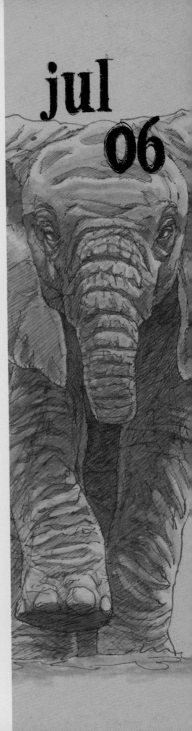

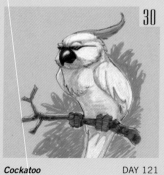

Cockatoo DAY 121
"Cockatoo Cool"
Home

Alien Primitive DAY 122
Home

Moth DAY 123
Requested by Thasja.
Home

Fox DAY 12
Home

Lion Studies DAY 128
Home

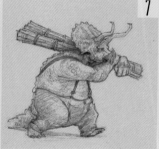

Triceratops DAY 129
ADI lunch break

Dream Stork DAY 130
I was visited by this hearty fellow in a
dream the previous night.
ADI & Northridge Food Court

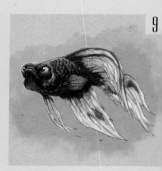

Beta Fish DAY 13
"Doug"
Our pet fish, drawn from life.
Home

Eyes DAY 135
"Locked in the Closet"
Mom & Dad's home, Minneapolis

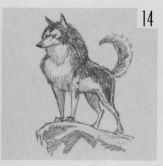

Husky DAY 136
Requested by my mom.
Cabin on Lake Superior, Croftsville, MN

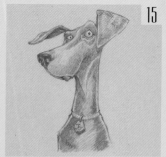

Weimaraner DAY 137
"Por Favor"
Requested by friend Tessa.
Cabin on Lake Superior, Croftsville, MN

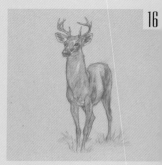

Deer DAY 138
Requested by my godmother, Joan.
Cabin on Lake Superior, Croftsville, MN

jul-
aug
06

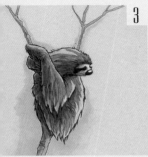

3

'oth DAY 125

s fur sometimes appears green due to
e symbiotic algae that grows on it.
ome

4

Bull DAY 126

ADI & Westfield Promenade Food Court,
Woodland Hills

5

Lion DAY 127

Home

10

'mperor Tamarin Emperor DAY 132

.DI lunch break

11

Ground Hornbill DAY 133

Based on a photo taken at the San
Diego Zoo.
Los Angeles International Airport, Gate 26

12

Manatee DAY 134

A belated birthday request from my sister,
Colleen. Based on a video freeze frame.
Mom & Dad's home, Minneapolis

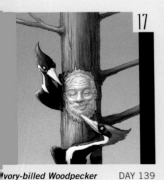

17

vory-billed Woodpecker DAY 139

'Ode to a Carver"
Requested by my dad.
Mom & Dad's home, Minneapolis

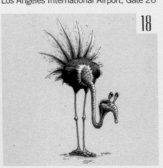

18

Alien Ostrich DAY 140

Mom & Dad's home, Minneapolis

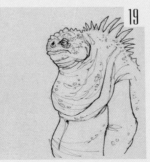

19

Marine Iguana DAY 141

Mom & Dad's home, Minneapolis

Moose DAY 142
Home

Wallowing Hog DAY 143
Home

Aquatic Dinosaur DAY 144
Home

Orca DAY 14
What if Nemo had been a killer whale
ADI lunch break

Beaver & Otter DAY 149
"Marty and Mo"
Loosely based on *The Odd Couple*.
Home

Ladybug DAY 150
"Where's the *love*, man?!"
Home

Slug DAY 151
Accurate description of my state of
being after playing roller hockey.
Home

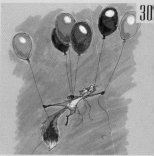

Squirrel DAY 152
"Unwanted Liftoff"
Home

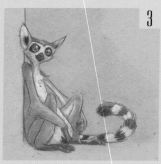

Lemur DAY 156
Home

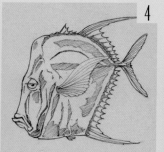

Lookdown DAY 157
Labor Day
Home

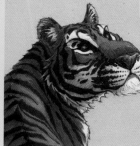

Tiger DAY 158
ADI & Northridge Food Court

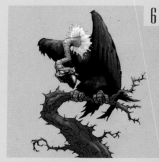

Vulture DAY 159
Venice Grind Coffee Shop & Home

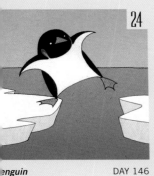

24

enguin DAY 146
Ambition"
ome

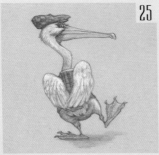

25

White Pelican DAY 147
"Paddy O'Pelly"
Media Center Mall Food Court, Burbank

26

Aardvark DAY 148
Yes, another aardvark fútboler. (See Day 058.)
Home

31

Rabbit DAY 153
Northridge Mall Food Court & Home

1

Rabbit Studies DAY 154
Northridge Mall Food Court

2

Gnu DAY 155
Also called a wildebeest.
Karen's house, Carlsbad, CA

7

Vulture DAY 160
"Snack Time?"
Northridge Mall Food Court

8

Elephant DAY 161
Home

9

Black Kite DAY 162
This was as far as I got before Thasja arrived and we went out for the evening.
Home

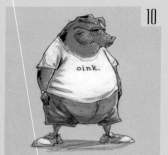

10

Pig
Home DAY 163

11

Bat
Home DAY 164

12

Python
"Sssssstorytime"
Northridge Mall Food Court DAY 165

13

Horned Cat
ADI lunch break DAY 166

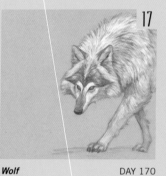

17

Wolf
Home DAY 170

18

Moose
Home DAY 171

19

Spider
Home DAY 172

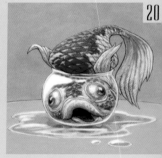

20

Goldfish
"Stuck"
Suggested by friend J.J.
Home DAY 173

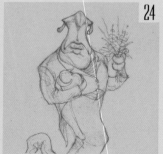

24

Love Slug
Home DAY 177

25

Alpaca
Home DAY 178

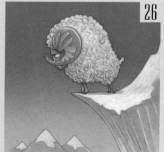

26

Ram
"Vigilance"
Home DAY 179

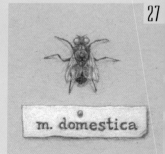

27

Common House Fly
Home DAY 180

T F S

14

15

16

umbats DAY 167
diurnal marsupial native to Western
ustralia whose favorite food is termites.
orthridge Mall Food Court

Crooked Giraffe DAY 168
A chiropractor's dream patient?
Home

Mantid Drummer DAY 169
Home

21

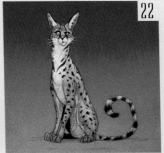

22

23

Evil Fuzzy Bunny DAY 174
Home

Serval DAY 175
Home

Serval Salescat DAY 176
Another character from my upcoming
children's book.
Home

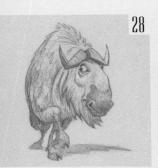

28

29

30

Takin DAY 181
Home

Takin DAY 182
Home

Chimpanzee DAY 183
Over the halfway mark of Volume One!
Home

S	M	T	W

1

Rhino DAY 184
Home

2

Furry Tree Dweller DAY 185
Packers: 9 - Eagles: 31 - Nuts!
Sonny McLean's pub, Santa Monica

3

Alien Possum DAY 186
Home

4

Wolf DAY 187
Similar to the wolf on Day 170 but
more caricatured.
Home

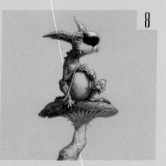

8

Enchanted Forest Inhabitant DAY 191
"Shroomination"
Home

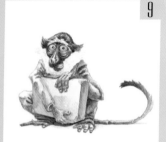

9

Diana Monkey DAY 192
"Insecure Traveling Salesmonkey"
Home

10

Hover Bug DAY 193
ADI lunch break

11

Baboon Studies DAY 194
Home

15

Bear DAY 198
"Big Bear, Small Trees"
Home

16

Thorny Devil DAY 199
Home

17

Wizard Lizard DAY 200
Home

18

Mouse DAY 201
I imagine it would be rather unpleasant to
have your tail stepped on by an elephant.
Home

5

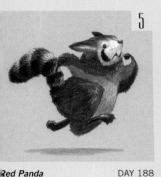

Red Panda DAY 188
"Red Run, Red Run!"
ADI, after hours

6

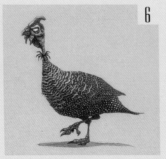

Helmeted Guinea Fowl DAY 189
Home

7

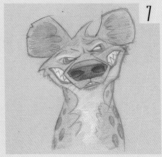

Hyena DAY 190
Home

12

Ostrich DAY 195
Home

13

Baboon DAY 196
A "construction study" - breaking down
the anatomy into simplified shapes.
Mar Vista Library

14

Bears DAY 197
Home

19

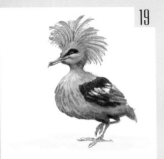

Victoria Crowned Pigeon DAY 202
Named for Queen Victoria, British mon-
arch for much of the 19th century.
Home

20

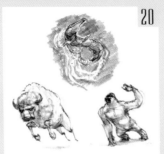

'Gator, Gorilla, Bison DAY 203
Small thumbnail studies.
Home

21

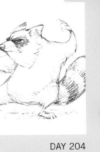

Raccoon DAY 204
"En Garde!"
Home

22

Opossum DAY 205
"Possum in a Pumpkin"
Done after carving pumpkins with friends.
Home

23

Gnu DAY 206
Home

24

Fish DAY 207
Home

25

Cotton-top Tamarin DAY 208
Home

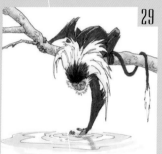

29

Colobus Monkey DAY 212
Home

30

Hound Dog DAY 213
"Sorry Kid, You Ain't Nuthin' But A..."
ADI

31

Mutant Penguins DAY 214
Halloween
ADI & Home

1

Gray Seal DAY 215
"Gregory the Gray Seal Contemplates
His Fleeting Existence in the Universe"
Home

5

Hippo DAY 219
Based on a photo taken at the LA Zoo.
Home

6

Cave Troll DAY 220
ADI

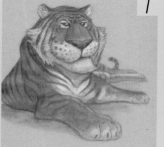

7

Tiger DAY 221
Election Day
Home

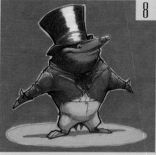

8

Ringmaster Mole DAY 222
Home

oct-nov 06

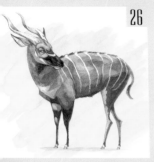

26

ongo DAY 209
ased on a photo taken at the LA Zoo.
lar Vista Library & Home

27

Basset Hound DAY 210
Home

28

Lava Croc DAY 211
Not to be confused with the similar-
looking Lava Gator.
Home

2

Heron DAY 216
ADI & Home

3

Mecha-Mouse DAY 217
A sort of robotic kangaroo mouse or
gerbil type thing.
Home

4

Puffin DAY 218
Home

9

Malayan Tapir DAY 223
Northridge Mall Food Court

10

Newt DAY 224
"Newt Neon to the Rescue!"
Character design for my children's book.
Home

11

Hungry Rocks DAY 225
Probably the loosest definition of the
word "animal" in Volume One.
Home

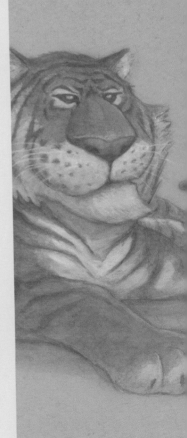

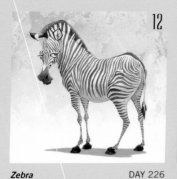

Zebra DAY 226
"One of A Kind"
Home

Mandrill DAY 227
Home

Black-footed Ferret DAY 228
Slowly reintroduced in the wild, only 18 of
this Endangered Species existed in 1986.
Home

Stork Chap DAY 22
UCLA Bowyer Oncology Clinic

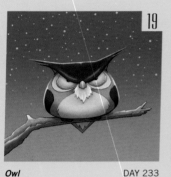

Owl DAY 233
Home

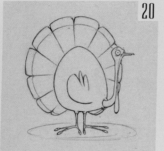

Turkey DAY 234
Drawn while watching the Charlie
Brown Thanksgiving special on TV.
Home

Toad Hostile DAY 235
Home

"Hug for Fluffy" DAY 236
For his birthday, Sean requested an
eel. Friend Paul added "dog."
Sean's apartment

Alien Hog Thing DAY 240
Jaxxon Bilch, intergalactic ambassador
from the Nebblix system.
Home

Grasshopper DAY 241
Packers: 24 - Seahawks: 34 - Nuts!
Sonny McLean's pub, Santa Monica

Stegosaurus DAY 242
Home

Beavers DAY 243
"Cannonball or Swan Dive?"
Home

nov-
dec
06

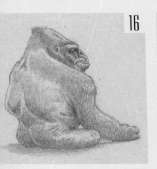
16

orilla DAY 230
orthridge Mall Food Court

17

Alien Crab DAY 231
Home

18

Pronghorn DAY 232
Home

23

Elephant Seal Princess DAY 237
"Her Heaviness"
Requested by Thasja on Thanksgiving.
Home

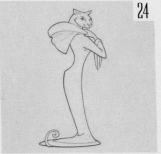
24

Puma Princess DAY 238
Stayed with the princess theme for
another day.
Home

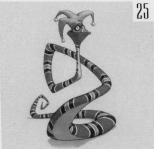

25

Snake DAY 239
"Serpentine Jester"
Home

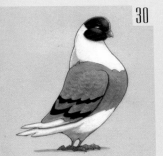
30

Pigeon DAY 244
Home

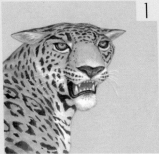
1

Jaguar DAY 245
Home

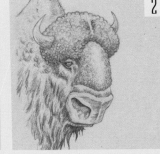
2

Bison DAY 246
Home

S M T W

Armadillo DAY 247
Home

Yeti DAY 248
Home

Elephant & Rhino DAY 249
Don Quixote & Sancho Panza, animal-
style. A fun, but unfinished, challenge.
Home

Giant Gourami DAY 2⁵
Southeast Asian freshwater fish pop
lar in aquariums and on the menu.
Home

Vulture Chemist DAY 254
Inspired by the film *The Constant Gardener*.
Home

Ram DAY 255
"Freedom!"
Home

Nessie DAY 256
Northridge Mall Food Court

Sheep DAY 25
Probably inspired by years of readin
Gary Larson's *The Far Side*.
Home

Tiger DAY 261
I was planning on coming back to this
one, but I kind of like it as is.
Home

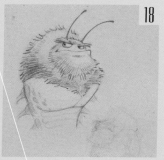

Tough Bumblebee DAY 262
Home

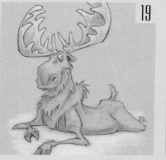

Moose DAY 263
Los Angeles International Airport, Gate 22

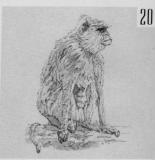

Patas Monkey DAY 264
Mom & Dad's home, Minneapolis

T　　　　　F　　　　　S

dec 06

7

...unt Moocula
...me　　　　　　　DAY 251

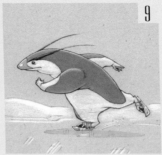

8

Bat Does Hamlet
Home　　　　　　DAY 252

9

Ice Mole
Home　　　　　　DAY 253

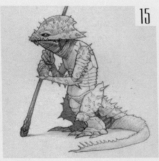

14

...ennec
...ome　　　　　　DAY 258

15

Reptilian Guard
Home　　　　　　DAY 259

16

Kangaroo
Home　　　　　　DAY 260

21

Blobbit
Mom & Dad's home, Minneapolis　DAY 265

22

Octopus
"Daddy O"
Mom & Dad's home, Minneapolis　DAY 266

23

Hippoescobaramus
Mom & Dad's home, Minneapolis　DAY 267

Abominable Snowman DAY 268
Christmas Eve
Grandma C's house, Green Bay, WI

Skunk DAY 269
"Stinky Santa"
Christmas Day
Grandma C's house, Green Bay, WI

Dinosaur DAY 270
Grandma C's house, Green Bay, WI

Porcupine DAY 27
Mom & Dad's home, Minneapolis

Giant Moa DAY 275
Extinct flightless bird of New Zealand.
Minneapolis-St. Paul International Airport,
Gate G9

Tiger DAY 276
"Burning Bright"
New Year's Day
Home

Long-nose Gar DAY 277
Home

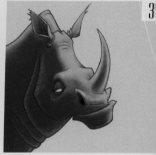

Rhino DAY 27
Home

Anteater DAY 282
Home

Marabou Stork DAY 283
Ugly but awesome.
Home

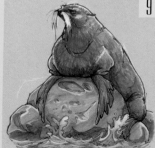

Alaskan Fur Seal DAY 284
Home

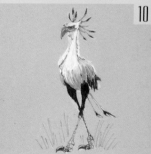

Secretary Bird DAY 285
Home

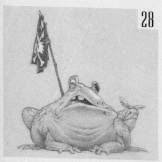

Frog Pirate 28 DAY 272
"Aaaaaarrrrrrgh-ibbit!" Shiver me timbers, I hope it's not a shaft in the aft!
Mom & Dad's home, Minneapolis

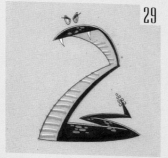

Snake 29 DAY 273
Sometimes I wish *my* eyeballs could float around independently of my head.
Mom & Dad's home, Minneapolis

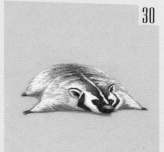

Badger 30 DAY 274
"Pooped"
Mom & Dad's home, Minneapolis

Green Sea Turtle 4 DAY 279
ADI lunch break

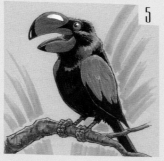

Helmet Vanga 5 DAY 280
Introduced to this species from Madagascar in an issue of *National Geographic*.
IKEA restaurant, Burbank, CA

Helmet Vanga 6 DAY 281
I was disappointed at how conservative the previous day's vanga turned out.
Venice Grind Coffee Shop

Puffins 11 DAY 286
Northridge Mall Food Court & Home

Lion 12 DAY 287
Northridge Mall Food Court

Elephant 13 DAY 288
"Saggy Undunt"
Home

dec-jan 07

14

Mr. Rabbit DAY 289
Home

15

Orangutan DAY 290
Based on a photo taken at Como Zoo,
St. Paul, MN.
Venice Grind Coffee Shop

16

Mutant Swine DAY 291
The result of a toxic waste dump being
located next to Farmer Jones' pig lot?
Home

17

Badger Scribe DAY 292
Inspired by attending a performance of
The Christmas Carol over the holidays.
UCLA Bowyer Oncology Clinic

21

Hornbill DAY 296
Home

22

Raccoon DAY 297
Home

23

Triceratops DAY 298
What if professional wrestling had
started in the Late Cretaceous Period?
Home

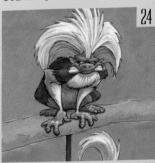

24

Cotton-top Tamarin DAY 299
Home

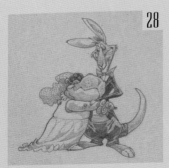

28

Hippo Bride & 'Roo Groom DAY 303
Done after a friend who liked hippos
married a bloke from Down Under.
Home

29

Japanese Macaque DAY 304
Home

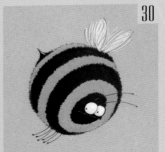

30

Bumbleblimp DAY 305
Home

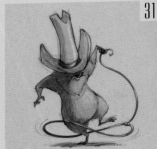

31

Gopher DAY 306
Grab bag: "Gopher" and "Licorice"
Home

Gibbon DAY 293
Home

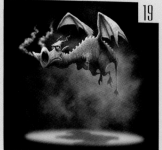

Dragon DAY 294
"Steamed"
Home

Armadillo DAY 295
Home

Jasper J, Coyote Crooner DAY 300
Every Thursday night down at the Ol'
Larkspur Inn off of Highway 32.
Home

Embarrassed Rabbit DAY 301
Drawn after an evening at the Magic
Castle in Hollywood.
Home

Giraffes DAY 302
"Eye to Eye"
Home

Crested Screamer DAY 307
This South American bird has one of
the loudest calls of the avian world.
Home

Groundhog DAY 308
Groundhog Day
Six more weeks of winter? Not in L.A.
Home

Red River Hog DAY 309
Home

jan-
feb
07

S M T W

4

White-faced Saki DAY 310
"Saki with Sake"
Home

5

Storkoise DAY 311
Home

6

Sheep DAY 312
"Scared Sheepless"
Home

7

Frog Waiter DAY 313
Home

11

Topi DAY 317
Topi are mid-sized antelope native to
African floodplains and savannas.
Home

12

Spiny Fish DAY 318
Home

13

Cyclops DAY 319
Home

14

Cyclopes DAY 320
Two cyclopes "complete each other" in
this Valentine's Day sketch.
Home

18

Alligator DAY 324
Used a 1923 photo of Walt Disney as
reference for his hat.
Home

19

Kookaburra DAY 325
A laughing kookaburra who's not exactly
laughing.
Home

20

Kookaburra DAY 326
Definitely laughing now.
Waiting room, Reproductive Tech-
nologies Lab

21

Baboon DAY 327
"Hangin' Out"
Home

T	F	S

8

ear
ome
DAY 314

9

Butterfly
Requested by Thasja.
Home
DAY 315

10

Kangaroo
Home
DAY 316

15

Frog Butler
"House Cleaning"
Home
DAY 321

16

Elephant
Home
DAY 322

17

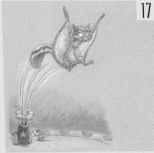

Flying Squirrel
"Phantastic Phil"
Requested by friend Shari.
Home
DAY 323

22

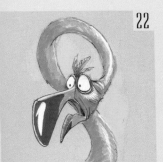

Flamingo
Home
DAY 328

23

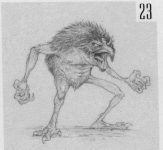

The Cruel Croll
Kids, eat your veggies.
Home
DAY 329

24

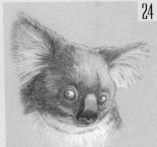

Koala
Home
DAY 330

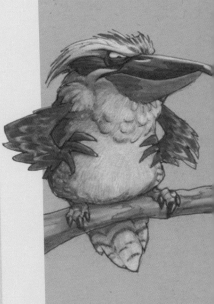

Rooster　　　　DAY 331
Home

Echidna　　　　DAY 332
Home

Raccoon Bandito　　　DAY 333
Grab bag: "Raccoon" & "Sombrero"
Home

Sea Lion　　　DAY 33

Home

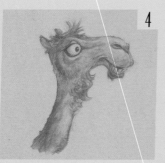

Dromedary　　　DAY 338
Home

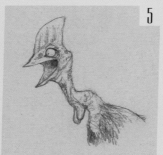

Cassowary　　　DAY 339
Scribble Exercise
Home

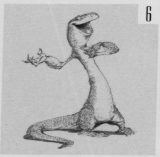

Goanna　　　DAY 340
Goannas, a type of monitor lizard, are
found in Australia and Southeast Asia.
Home

Tasmanian Devil　　　DAY 341
Home

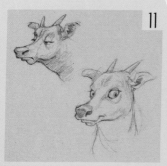

Lowland Anoa　　　DAY 345
This relative of the buffalo is native to
the Indonesian island of Sulawesi.
Home

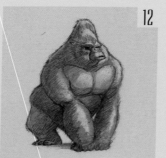

Gorilla　　　DAY 346
Home

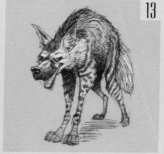

Striped Hyena　　　DAY 347
Outside the Wiltern Theatre, waiting to
meet Thasja for a Patty Griffin concert.
Corner of Wilshire & Western, L.A.

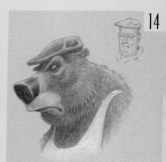

Waiting Room Bear　　　DAY 348
Based (loosely) on a gentleman sitting
on the other side of the waiting room.
UCLA Bowyer Oncology Clinic

feb- mar 07

1

Parrot DAY 335
The final countdown — one month to go in Volume One of *The Daily Zoo!*
Home

2

African Crowned Crane DAY 336
Home

3

Dromedary DAY 337
Home

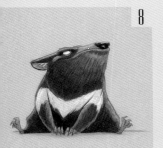

8

Tasmanian Devil DAY 342
Home

9

Alien Eel DAY 343
Home

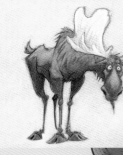

10

Moose DAY 344
"Wilbur Slowly Realizes He Forgot Where He Parked"
Bourbon St. Shrimp Co. & Home

15

Weedy Sea Dragon DAY 349
"Lenny"
Northridge Mall Food Court

16

Ostrich DAY 350
Home

17

Pterodactyl DAY 351
Home

18

Pterodactyl DAY 352
Home

19

Tree Frog DAY 353
Home

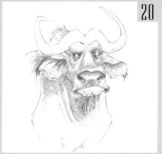

20

African Buffalo DAY 354
Home

21

Beluga Boy DAY 35
Home

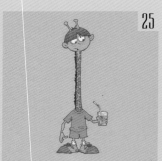

25

Christopher Giraffe DAY 359
Home

26

Furious Frilled Lizard DAY 360
Home

27

Space Bunny DAY 361
I believe I saw this guy as I was drifting
off to sleep one night.
Home

28

Quoll DAY 362
Quolls are carnivorous marsupials native
to Australia.
Home

T F S

22

ngolan Free-tailed Bat DAY 356
ome

23

Doberman Pinscher DAY 357
Northridge Mall Food Court

24

Japanese Macaque DAY 358
Based on a photo by Steve Bloom.
Home

29

-rex DAY 363
Home

30

Lion DAY 364
Home

31

Tortoise DAY 365
"Finished at the Finish"
Home

mar
07

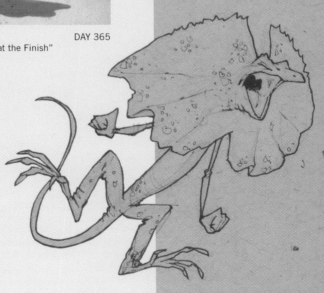

afterword

For all its rigor, its time-consuming repetition and reiteration, and the necessary disappointments, the study of Medicine, and the care of patients with acute leukemia, permit a doctor great insight into human behavior, and a great opportunity to observe the motivations, achievements, and failings to which we human beings are susceptible. We are very fortunate that patients like Chris are willing to educate us, not only about how to use, or not to use, a certain drug or treatment, but how to proceed through the often tortuous and conflicting paths of therapy. The lessons which patients teach include the value of self-discipline, the impact of an individual's background on his personality and decision-making, and a person's drive to express his/her uniqueness. Chris, with his book, shows us an element of his own uniqueness, and we learn from him the unique nature of our own purpose, always in struggle, never quite achieving what we need to achieve, but always working for that ultimate goal of conquering a disease.

Gary Schiller, M.D., F.A.C.P.
Professor
Director
Hematological Malignancies/Stem Cell Transplantation Unit
David Geffen School of Medicine at UCLA

acknowledgments

To Thasja:
On so, so many levels this book would not have been possible without you. From spending every night by my side at the hospital during my cancer journey to your artistic feedback and patience during this book journey to your love on all journeys. Thank you for opening your arms and your heart to me and all of my furred, feathered, and finned friends.

To Mom, Dad, and Colleen:
Thank you for your tireless and unwavering encouragement, love, and support – not just on this project but all of them, from fingerpainting to book creation.
And thanks for taking me to the zoo.
(Thanks too for the nickname, Mrs. P.)

To J.J.:
Thank you for crafting such rich and wonderous tales full of action, adventure, and the struggles of human emotion. They provided distraction at a time when I needed it most. And thank you for making my year by contributing to this book in such a heartfelt manner. *You* are the Mad Genius.

To Patch:
Your work and vision is inspirational. Thank you for sharing your gifts with so many and showing us just how easy it is to see the humanity in each other.

To Dr. Gary Schiller & the UCLA team:
You have difficult jobs – jobs that require great knowledge, compassion, dedication, attention to detail, and inner strength – so much so that they transcend being just a job and become a lifestyle. Thank you for choosing that path and doing it so well. I am glad I was in your hands.

To my friends and family:
Thank you for being my vast army of love and support who held me, carried me, cheered me, and encouraged me on my cancer journey and the journey of *The Daily Zoo*. Thank you for being my tigers, burning bright….

To my artistic brothers & sisters, teachers & mentors:
Thank you for sharing your creativity, knowledge, and being a font of inspiration. I can only hope I am returning the gesture in some small way.

To the Design Studio crew:
Scott Robertson, thank you for the many exciting opportunities this past year, the greatest of which was getting a chance to share my zoo with others on a grander scale. Thanks for believing in my vision. **Tinti Dey**, thank you for your serenity, wisdom, and hard work to make this dream come true. **Melissa Kent**, thank you for your wordsmithing and three degrees of separation. **Jason Mitchell**, thank you for working your magic and holding a megaphone to the voice of the *DZ*. **Daniela Tomas & Sergio Garcia**, thank you for your help in getting this book into readers' hands.

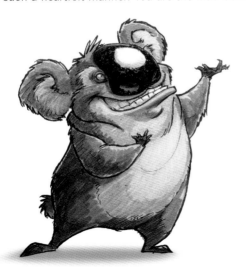